IMAGES
of America

SURFING IN
HUNTINGTON BEACH

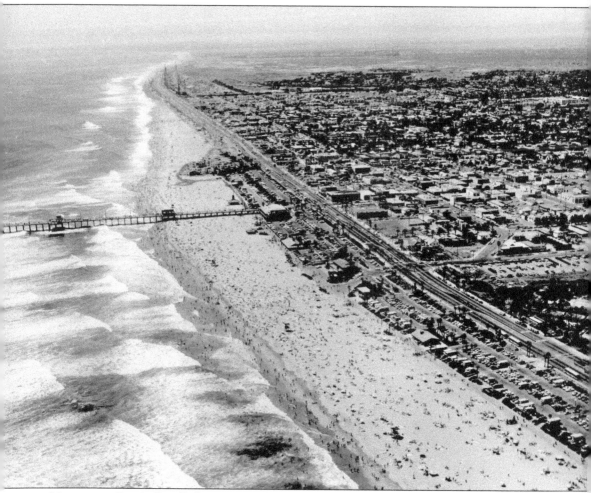

Huntington Beach (locally known as HB) boasts nearly 10 miles of uninterrupted beach and rideable waves formed along a sandy-bottom beach break. The focal point is the famous pier. Further up is Huntington Cliffs, followed by the coastal wetlands of Bolsa Chica. This 1980s aerial taken south of the pier looking north captures one of the most consistent wave zones in all of Southern California. (Courtesy of the City of HB Archives.)

ON THE COVER: This iconic photograph showcases a group of surfing legends and their balsa boards beside the HB pier around 1955. Some were born here and others drawn to it, but all embody Huntington Beach's surfing spirit. For a listing of those pictured, see page 31. (Courtesy of Bruce Brown Films, LLC © 1964, 2018.)

IMAGES
of America

SURFING IN
HUNTINGTON BEACH

Mark Zambrano

ARCADIA
PUBLISHING

Published by Arcadia Publishing
Charleston, South Carolina

Library of Congress Control Number: 2018956178

For all general information, please contact Arcadia Publishing:
Telephone 843-853-2070
Fax 843-853-0044
E-mail sales@arcadiapublishing.com
For customer service and orders:
Toll-Free 1-888-313-2665

Visit us on the Internet at www.arcadiapublishing.com

This book is dedicated to the Huntington Beach surf community.

CONTENTS

Acknowledgments

No book is an island. Thank you to the surfers, shapers, historians, photographers, businesses, and residents who generously donated their time, photographs, and memories to this collection. Without them, this would not have been possible, or as meaningful. These include George Strempel and Jerolyn Becker for sharing an oft forgotten history; Duline McGough for connecting me to a world of surfing I never thought possible; John Van Oeffelen for helping navigate the compass to success; Bob Bolen for keeping an open door to his amazing surf museum; Jeri Macres and husband, Steve, for sharing her father Rocky Freeman's words; Tani Church for donating photographs from her father Ron's collection; Tom Gibbons for his valued insight and epic handshakes; and Lee Willmore for his great shots and great sandwich; as well as everyone else who showed me the breaks, including Harlo LeBard, Chuck Linnen, Chris Cattel, Steve Brom, Rod Treece, Randy Lewis, Pete Siracusa, Roy Crump, Jon Overmeyer, Dean Torrence, Lewie Derigo, Rockin' Fig, Bill Fury, Rick Blake, Bud Llamas, Erin McNally, Jim Driver, Brad Driver, Terry Eselun, Jericho Poppler, Corky Carroll, Bruce Gabrielson, Tina Toulouse, Douglas Miller, Randy Nauert, David and Duane Wentworth and the Huntington Beach Historic Resources Board (HBHRB), David Lessard, Jerry Person, Kai Weisser, John LaRoche, Michael Curtiss, Julie Toledo, Kreg Jones, Chris Andrade, the Facebook group "You know you grew up in Huntington Beach, CA when . . . ," and Orange County archivist Chris Jepsen.

Sources include *Ebb & Flow: 100 Years of Huntington Beach* (Joe Santiago, HBHRB, 2009), *The History of Surfing* (Matt Warshaw, 2010), *Huntington Beach News* archives, *Huntington Beach: An Oral History* (California State University, Fullerton, 1980), and *A Voyage to the Pacific Ocean* (James Cook, 1784).

Additional thanks to Diana Dehm and Huntington Beach International Surfing Museum (HBISM), Susan Thomas and Visit Huntington Beach, Rachel Scandling of Redondo Beach History Museum, Glenn Brumage and Barry Haun of Surfing Heritage and Culture Center (SHACC), Jack Clapp of Dwight's Beach Concession, Alex Mecl of Bruce Brown Films, Cheryl McKenzie of Huntington Beach Union High School District, Poppy Holguin of Jan's Health Bar, Caroline Anderson of Arcadia Publishing, and DocumentaryMe filmmaker Brad Rettele.

A special thanks to my historian guru, Kathie Schey, for welcoming me into the vault and taking this project on as her own.

Finally, thank you to my family. Thank you, Aunt Diane, for writing; Chris, for editing; Myron, for your jokes; my wonderful mom and dad, for showing me the way to the waves; and my beautiful Twick, for joining me on the ride.

INTRODUCTION

"You should have been here yesterday."

One of the first known written accounts of surfing comes care of a 1777 journal entry by William Anderson. Anderson was a crew member aboard Captain James Cook's voyages across the Pacific. While anchored in Tahiti's Matavai Bay, he describes watching a native catch a wave on an outrigger:

> He went out from the shore till he was near the place where the swell begins to take its rise; and, watching its first motion very attentively, paddled before it with great quickness, till he found that it overtook him, and had acquired sufficient force to carry his canoe before it without passing underneath. He then sat motionless, and was carried along at the same swift rate as the wave, till it landed him upon the beach. Then he started out, emptied his canoe, and went in search of another swell. I could not help concluding that this man felt the most supreme pleasure while he was driven on fast and so smoothly by the sea.

Not much has changed in 200 years.

All those who have followed suit and taken to the waters are trying to achieve the same stoke felt by that 18th-century Tahitian on his canoe. Some say humans riding waves dates as far back as 3,000 BC with ancient Peruvian fisherman riding their canoe-like *caballito de totora* (little reed horses). Stand-up surfing, as we know it today, is said to have emerged around 1,000 AD in Hawaii, referred to as *he'e nalu* (wave-sliding). Regardless of when or where it began, it was evident right from the start what surfing was really all about. As one of the most famous surfing quotes (often attributed to Phil Edwards but more likely from his biographer Bob Ottom) proclaims, "The best surfer is the one having the most fun." Anyone who's ever been to Huntington Beach can attest to that.

Huntington Beach has had many names over the years. Shell Beach. Pacific City. Oil City. Today, it is best known as "Surf City." Of all its names and claims to fame, this one is most meaningful. The city of Huntington Beach was built around the surf breaking on its shores and has ridden the waves of progress they have provided ever since.

Even the most land-bound of residents take pride in Huntington Beach's surfing roots. Surfers, both young and old, catching waves by the pier, congregating at surf shops on Main Street, shaping boards out of their garages and backyards, and talking story to any and everyone who will listen, know that HB is a surf community in the truest sense of the term. Nearly all those who call it home, across all generations, are linked thanks to the local endearing spirit of surfing.

Huntington Beach's first inhabitants were the indigenous Tongva. The area was later claimed by the Spanish and then became part of Mexico until ceded to the United States in 1848. Vast

cattle ranchos were eventually replaced by farmers. In 1909, it was incorporated as a city and over the next 100-plus years would ride an ebb and flow of change brought on by developers, entrepreneurs, laborers, travelers, and other visitors to its shores. Of all those, the close-knit group of surfers, beach beatniks, and surf rats riding its endless waves has had one of the most important roles in turning Huntington Beach into what it is today.

What follows is a collection of photographs and stories showcasing the role surfing has played in the history of Huntington Beach and the role Huntington Beach has played in the history of surfing. What lies within only scratches the surface of this long and storied past. To truly do it justice one would need an ocean of space to chronicle HB's incredible lineup of characters and moments. The exclusion of any of these greats is unintentional. If nothing else, hopefully, this collection will inspire a deeper look into the far-reaching ground swells that have given rise to surfing in Huntington Beach over the years.

Ask any surfer in town, and they will tell you surfing is a way of life. It sounds like a cliché, but that just means you haven't spent enough time in the water. These are people that eat, sleep, and dream surfing. These are the ones that surf for surfing's sake. If you took away all the contests, money, magazines, movies, fashion, and trends, they would still be right there on the beach, ready to drop everything the instant a south swell started rolling in. This is Huntington Beach's surf family. It began with a small group of dedicated watermen hauling huge planks into the water and grew into a beach town like no other.

There is a telling moment in filmmaker Brad Rettele's documentary of local surfing great George Strempel that perfectly sums up the spirit of surfing in HB. After reflecting on all the memorable moments over the years, Strempel finally admits, "We didn't know we were making history."

Probably because they were having too much fun.

One

THE PIONEERS
1914–1927

Surfing in Huntington Beach started with George Douglas Freeth Jr. Born in Oahu in 1883, Freeth was a gifted waterman, champion swimmer, acrobatic high diver, and exceptional stand-up board rider in the nearly forgotten Hawaiian tradition of *he'e nalu*. Growing up on the beaches of Waikiki, Freeth crossed paths with travel adventure writer Alexander Hume Ford. In the wake of missionaries having all but killed off the sport for its "barbarism," Ford was instrumental in the early promotion of both Hawaii and the culture of surfing. He enlisted Freeth to help, and on July 3, 1907, Freeth boarded a passenger ship bound for San Francisco to spread the word. The front-page of the island's main paper, the *Pacific Commercial Advertiser*, heralded the event with the headline "George Freeth Off to Coast—Will Illustrate Hawaiian Surfriding to People in California."

Three weeks later, Freeth was spotted surfing Venice Beach. Not long after, the 23-year-old caught the eye of Henry Huntington, a railway magnate engrossed in massive coastline real estate development. To promote his new projects, Huntington hired Freeth to serve as a lifeguard, swimming instructor, and rider of waves in exhibitions at Redondo Beach, where he was hailed as "the man who walked on water." At the time, Henry Huntington's community projects were connected by his sprawling interurban Pacific Electric Railway, known as the "Red Car" system. Huntington utilized Freeth's circus-like wave-riding talents to promote his railroad and draw visitors to his newly developed destinations along the route. At the start of the 20th century, this included a roughly two-block coastal resort community named after its industrialist backer called Huntington Beach.

On June 20, 1914, this traveling one-man board-riding road show would go down in history as the first recorded surfer to hit the waves of what is now known as Surf City, USA.

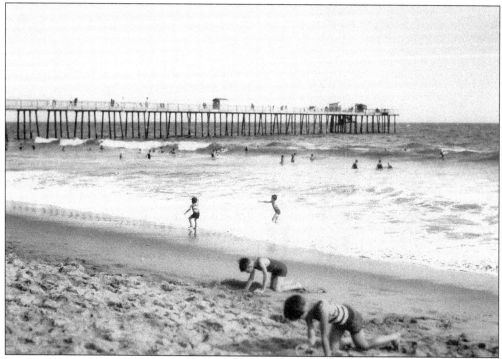

In 1904, within a year of its name change from Pacific City to Huntington Beach, a wooden pier was built 1,000 feet into the Pacific Ocean. In this photograph, around the time HB was incorporated as a city in 1909, young children play in the sand, people promenade the wooden pier, and, most notably, several swimmers bodysurf. (Courtesy of the Orange County Archives.)

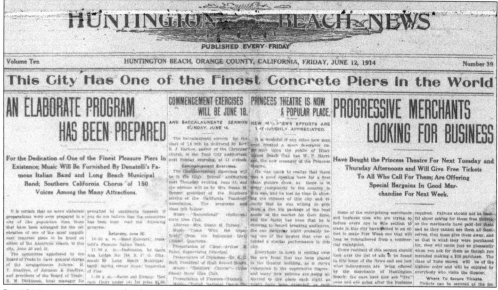

In 1912, a storm severely damaged the wooden pier. At the behest of town visionary Thomas Talbert, construction of a new one was approved for $70,000. This edition of the *Huntington Beach News* announced the rededication festivities, with George Freeth scheduled to demonstrate "surf board riding" shortly after 2:30. (Courtesy of the HB Public Library.)

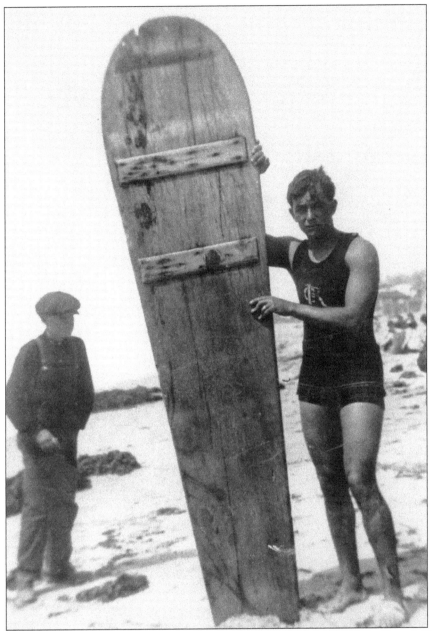

When George Freeth came to California, he used a tapered wide-nosed redwood board. Here, in Redondo Beach, Freeth holds that board, with cross-battens affixed to repair vertical cracking. During Freeth's wave-riding exhibitions in Redondo, the announcer proclaimed his board was eight feet long and two feet wide, weighing more than two hundred pounds. There are no known photos of Freeth's historic ride in Huntington Beach on Saturday, June 20, 1914. Reporting afterward, *Huntington Beach News* wrote, "George Freeth was enjoyed by several thousand, as those stationed east side of the pier could see him while riding the waves with the ease and grace of a sea gull." It should be noted some surf historians believe Freeth may have surfed Huntington as early as 1907, though to far less fanfare. (Courtesy of the Redondo Beach Historical Museum, original image on loan from A.R. "Red" Allison.)

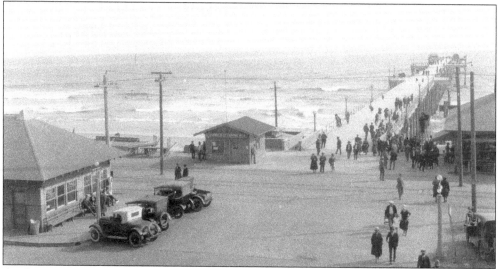

At the time, Huntington Beach's finished 1,350-foot structure was the longest and highest concrete "pleasure pier" in the United States. This view shows the two-way breaking waves on the pier's east side, where Freeth rode. Today, this surf spot is known as South Side. (Courtesy of the Orange County Archives.)

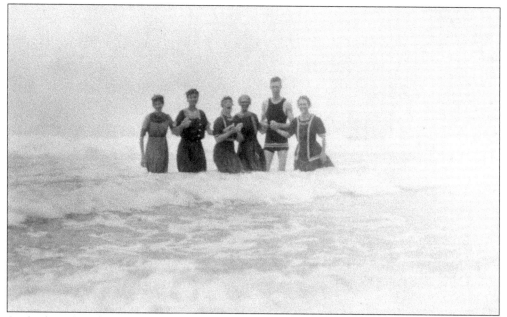

Surf culture has always been linked just as much to what happens by the shore as it does on the waves. To give an idea of the type of youthful beachgoers prevalent during Freeth's visit, here is a photograph of several captioned as "Vera Robinson and friends in the surf circa 1914." (Courtesy of the Orange County Archives.)

Freeth, along with many of the visitors traveling to the beach for the rededication, arrived via the Pacific Railways "Red Car." In this early-1900s photograph, No. 1044 passes through on its way to Newport Beach, providing a perfect view of HB's peeling waves along the way. (Courtesy of the City of HB Archives.)

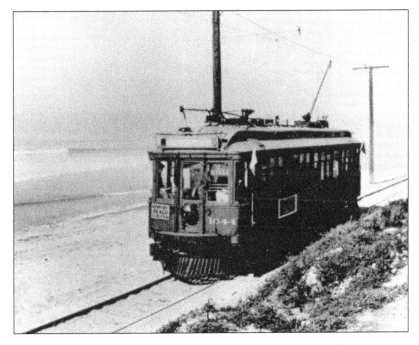

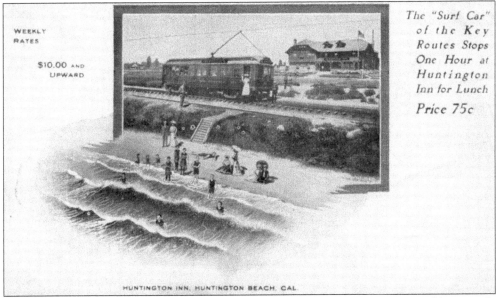

Henry Huntington used his rail system to promote the area as a vacation spot and lure people into buying property. Day-trippers were more than happy to oblige, funneling in on the "surf car" to play in the waves and have lunch at the nearby Huntington Inn. (Courtesy of the Orange County Archives.)

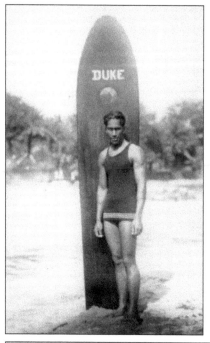

Despite the momentousness of George Freeth's 1914 ride, his accomplishment had little immediate impact and was largely forgotten. It might have remained so, with surfing nothing more than a vestige of ancient Hawaiian tradition, if it were not for Duke Kahanamoku. A five-time Olympic medalist, lifeguard, boardmaker, Waikiki Beach Boy, and indelible waterman, Duke Paoa Kahinu Mokoe Hulikohola Kahanamoku is the father of modern surfing. (Courtesy *Aloha from Honolulu*.)

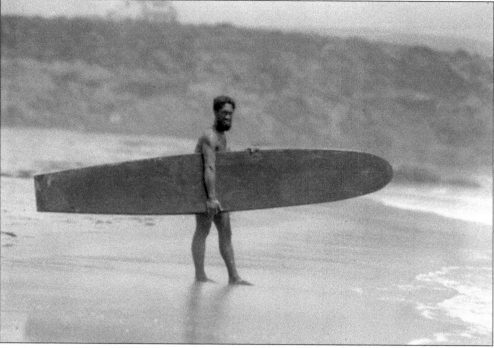

Growing up in Hawaii, Duke attended exhibitions by Freeth. Following his lead, Duke became a worldwide surfing ambassador. After winning gold in the 100-meter freestyle at the Stockholm Olympics, Duke introduced surfing to Australia around 1914. Later, he came to California to work as an actor, seen here around 1920 in Los Angeles, sporting one of his famous longboards and an epic beard. (Courtesy of the University of California, Los Angeles [UCLA] Library, CC By 4.0.)

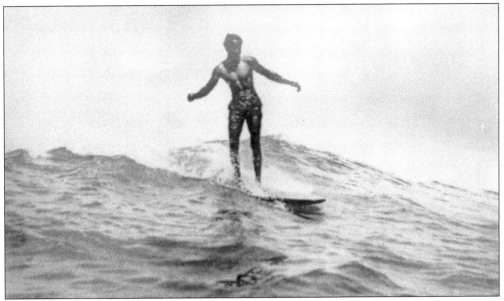

Duke Kahanamoku surfs Waikiki around 1910 in a shot from the first book of surfing photography, *The Surf Riders of Hawaii*. Thanks to Olympic fame and Hollywood connections, Duke caused a sensation anytime he took to the water. It was during a session while filming a movie at Corona Del Mar that he caught the eye of two Huntington Beach residents. (Courtesy of the California History Room, California State Library, Sacramento, California.)

Delbert G. "Bud" Higgins and Gene Belshe were Huntington Beach's first full-time lifeguards. Bud (right) is seen here in 1928 with Gene and his wife, Johnnie Belshe. In the mid-20s, Bud and Gene went down to watch Duke surf the Corona Del Mar jetty. They introduced themselves and took the opportunity to examine the Hawaiian's board. Thus began HB's endless fascination with the "sport of kings." (Courtesy of Rod Treece.)

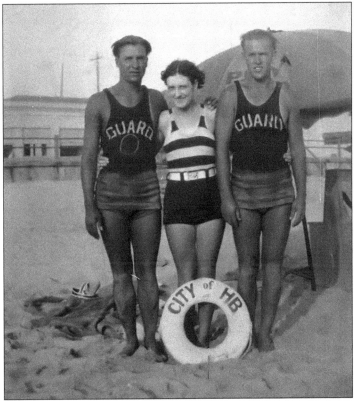

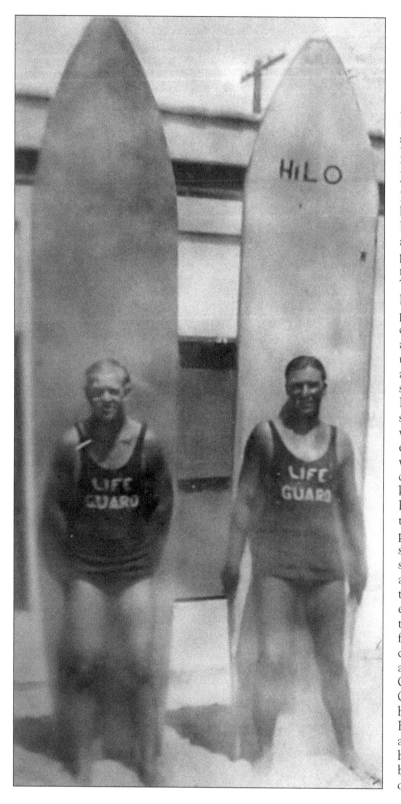

After being introduced to surfing by Duke Kahanamoku, Higgins and Belshe went to a nearby lumberyard and bought a 20-foot-long, 24-inch-wide, and 3-inch-thick plank of kiln-dried redwood for $40. They cut it in half, laid their 10-foot planks on 50-gallon drums on the beach, and in August 1927, used a block plane and drawknife to shape Huntington Beach's first two surfboards. They weighed 135 pounds each. While they worked as lifeguards during the day, local kids took turns learning to ride on these makeshift planks. Before long, several more newly shaped boards appeared around the pier. By Bud's estimate, in 1927, there were three to four non-Hawaiian crafted boards in all of Southern California. By 1929, Orange County had around a dozen. Bud (left) and Gene are pictured here holding their first boards. (Courtesy of Rod Treece.)

Two

Oil, War, and Keoki
1920–1950

There have been two great booms to rock Huntington Beach. The first came on May 24, 1920, when "Discovery Well" blew.

It might not seem like surfing and oil have a whole lot in common. And while that might be true for most places, the two have been intricately linked throughout Huntington Beach's history.

At the start of the 1920s, the Standard Oil Company of California was looking for places to drill for oil. They settled on an area by Goldenwest and Clay Streets and erected a derrick named Huntington A-1. After this newly discovered well's initial success, a second was quickly set up. That one immediately started producing a gargantuan 1,742 barrels a day, and Huntington Beach never looked back.

When George Freeth first surfed the pier in 1914, the city's population was 1,400. By 1920, it was 1,680. Within a year of that first oil strike, it skyrocketed to over 7,000.

Despite its early rise as a resort town, the area quickly took a decidedly different turn once black gold entered the picture. Real estate prices soared, an influx of wayward workers rolled in on the Red Car, commerce followed, and miles of towering derricks rose up all along the coast. World War II only helped further the change. Amidst this shift, surfing quietly took root in Huntington Beach, thanks in large part to a small group of friends known as the Keoki Club.

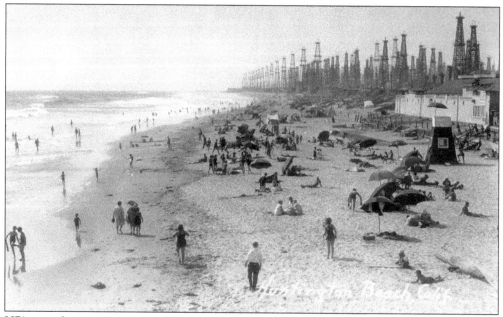

HB's transformation into an oil boomtown was evident everywhere one looked, with a skyline jarringly resembling a dystopian future. However, looming derricks were not enough to keep people from still enjoying a day at the beach, as evidenced by this c. 1930 crowded scene. (Courtesy of the Orange County Archives.)

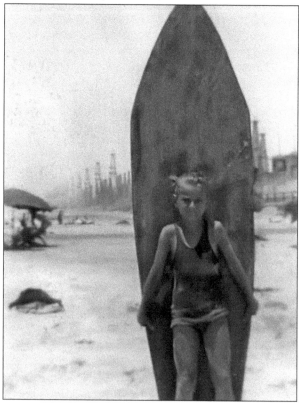

In perhaps what might be the first documented "gremmie" of Huntington Beach, a youngster holds a massive handcrafted slab of lumber inspired by the boards of Bud Higgins and Gene Belshe around 1928. The term "gremmie," which was later usurped by the similarly meaning "grommet" used in Australia, is slang for a young surfer and derived from a small mischievous gremlin. (Author's collection.)

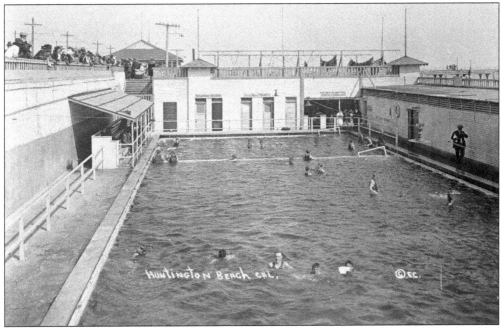

Bud and Gene's surfboards required constant varnishing to stay afloat. To fix waterlogging, they were placed in a towel drying room at the Saltwater Plunge. Open from 1911 until the 1960s, "the Plunge" was a popular shore-side pool north of the pier filled with heated ocean water for wave-free swimming. It also proved an ideal place to store 135-pound surfboards. (Courtesy of the Library of Congress.)

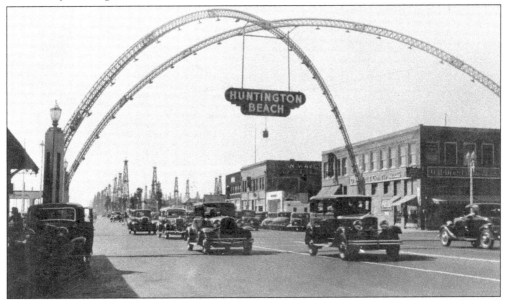

Between 1927 and 1932, Bug Higgins surfed along the coast thanks to the Pacific Coast Highway (PCH), which opened in 1926. Until then, Ocean Avenue, HB's main coastal auto artery, stopped near what is now Goldenwest Street. Bolstered by the oil boom, the PCH paved the way for commerce, entertainment, and surf safaris. The arches were erected in 1929. The corner Rexall drugstore is the future home of Jack's Surfboards. (Courtesy of the City of HB Archives.)

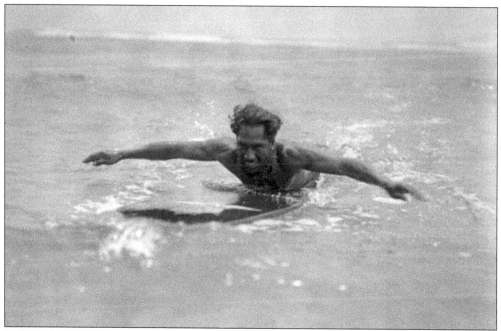

Duke Kahanamoku paddles out around 1920 into Southern California waters. After several more trips to see Duke, Bud Higgins invited him and his Hawaiian friends to surf HB. No photographs of those visits exist, but they reportedly rode several times on the pier's north side. And with that, HB was officially christened a legit surf spot. (Courtesy of the UCLA Library, CC By 4.0)

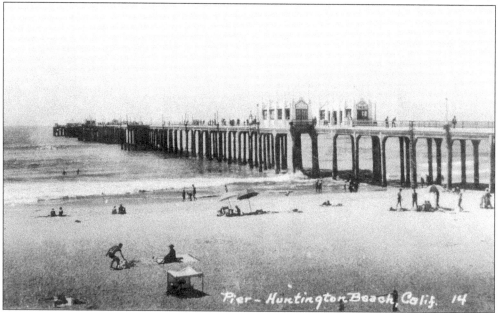

When this photograph was snapped, most likely in the early 1940s, the unofficial sport of HB was jumping off the pier. A ladder on the beach (seen right) allowed bodysurfers and bellyboarders to quickly get outside the break to catch a wave, ride it to shore, and repeat. Here, three bellyboarders (or perhaps, even early kneeboarders) enjoy South Side almost entirely to themselves. (Courtesy of the City of HB Archives.)

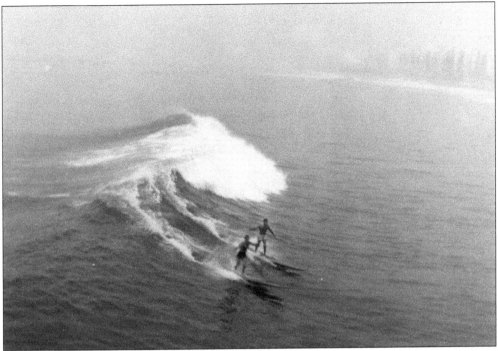

Two surfers ride North Side, with oil rigs standing sentry along the coast faintly behind them. A rare sight by today's standards, surfers during this time had the waters practically all to themselves. (Courtesy of Harlo LeBard.)

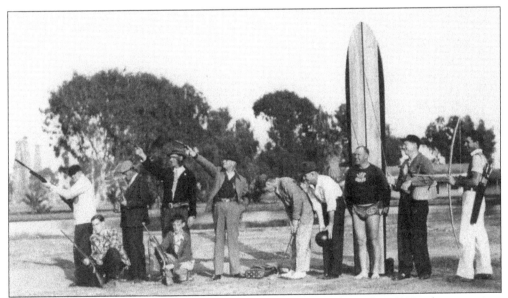

Helping to promote surfing, Bud Higgins joined a gathering at Lake Park in 1939 to honor various HB sports. From left to right are Roy Rafferty (skeet shooting), two unidentified boys kneeling from Dodge Rifle Club, Perry Huddle (camera), Jim Clark (handgun), Rev. Luther Arthur (handgun), Clayton Alredge (golf), Mickey Rafferty (bowling), Higgins (surfboarding), Beryl Harper (fly casting), and Bill Wardwell (archery). (Courtesy of the City of HB Archives.)

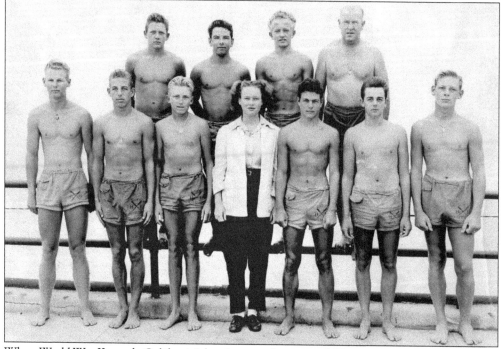

When World War II struck, California's beach scene disappeared. The pier became a Navy lookout post and gunnery, and able-bodied lifeguards went overseas. Bud Higgins, who by then was the city's first full-time lifeguard chief, replaced his crew with high schoolers such as these pictured with him in July 1944. Second from the bottom right is Harlo LeBard, a member of HB's latest generation of surfers. (Courtesy of the City of HB Archives.)

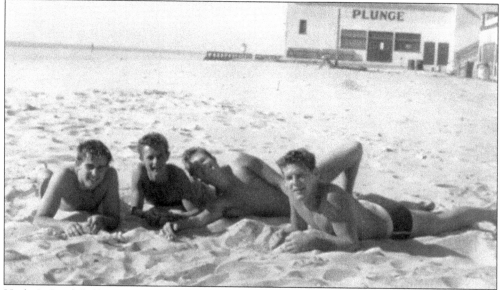

Harlo LeBard (left) is joined by friends Rocky Freeman, Kenny Bruce, and Loren Thornton in front of the Saltwater Plunge. One day while bodysurfing South Side, a surfer named Art Beard rode up and asked who was the lightest of the group. The 11-year-old Rocky won, and before Rocky knew it, he was tandem surfing in epic three footers. (Courtesy of Harlo LeBard.)

Rocky's first board came courtesy of his next-door neighbor, Gene Belshe. Gene sold Rocky an old hollowed redwood board with metal skeg for a small fortune of $12. It took two to carry and had to be drained after each session using a plug in its nose. Rocky soon found less imposing boards to ride and, in no time, became HB's top local surfer. (Courtesy of Jeri Macres.)

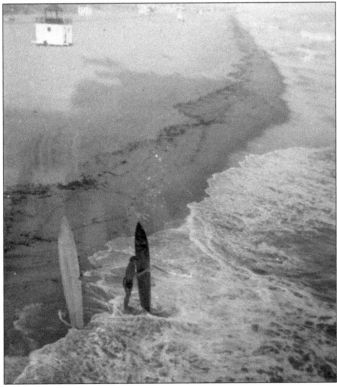

Rocky made his first surfboard in the mid-'40s out of his family garage on Sixth Street, self-dubbed "Rock's Board Shop." During the day, he shaped while working at lifeguard headquarters, painting the board red so it looked like he was making a rescue board. This photograph shows Rocky holding that board at water's edge with Harlo LeBard, hidden behind a nine-foot balsa he similarly shaped himself. (Courtesy of Harlo LeBard.)

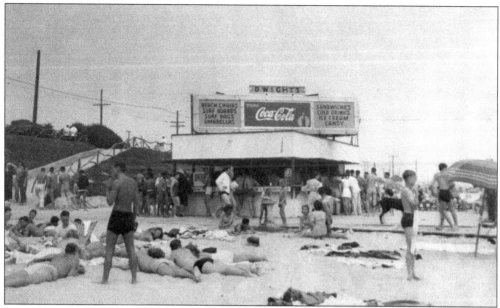

Jack Clapp remembers looking over from his family-run concession and seeing Rocky shaping atop the pier. Dwight's Beach Concession was opened by Jack's father in 1932 attached to the original lifeguard tower. In 1939, Dwight's moved to its own building and expanded its services to appeal to the surfing crowd. This July 4, 1944, photograph shows what is likely HB's first board rental business. (Courtesy of Jack Clapp.)

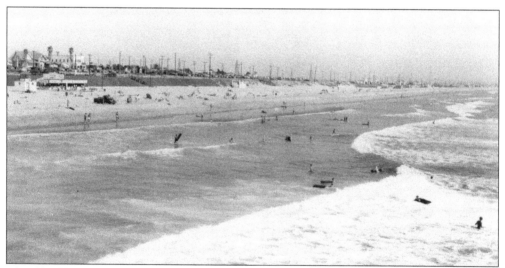

The all-rubber Surf-o-plane was invented in 1934. By the late 1940s, these surf mats were popular throughout Southern California. They could be rented at concession stands like Dwight's (seen left on the beach behind the original lifeguard tower). The first time many ever rode a wave standing up was on one of these inflatable surf-riders. (Courtesy of the Orange County Archives.)

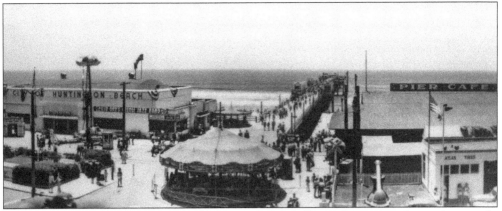

During the war, a breakwater was built in Long Beach killing off a great surf spot. As a result, in the words of Rocky Freeman, "The crowd grew in the surfing world of H.B." When the war ended, beachgoing also grew, as seen here July 4, 1946. The Pav-A-Lon Ballroom, a popular music hall (and roller rink) amongst surf bands and their fans, is seen at left. (Courtesy of the City of HB Archives.)

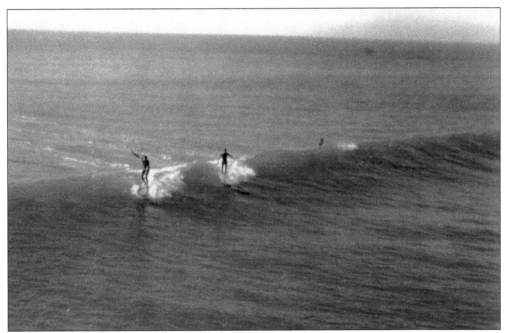

Two great things to come out of the war (at least for surfers) were fiberglass and a surplus of balsa. South Gate's General Veneer and the nearby San Pedro lumberyard supplied many local surfers' shaping habit, including Rocky Freeman (right) and George Strempel, seen riding together in 1946 on an all-balsa board and balsa redwood board, respectively. (Courtesy of George Strempel.)

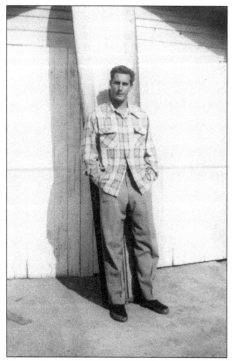

George Strempel, also known as "Gorgeous George," got his start hitchhiking to the pier with a homemade plywood bellyboard and swim fins. After serving in the Navy during the war, he returned where he left off and met Rocky Freeman. Together, they shaped boards out of Rock's Surf Shop. Strempel stands before the Sixth Street garage around 1948 with a recently made balsa redwood surfboard. (Courtesy of George Strempel.)

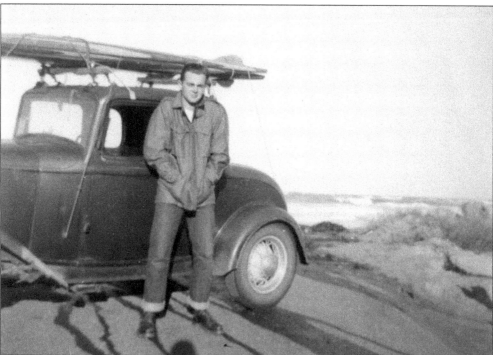

Just like Bud Higgins before them, when not shaping and riding the pier, HB's latest clan of surfers explored the coast in search of waves. Here, on one such trek in December 1949, a noticeably chilled Harlo LeBard stands beside his 1932 Ford at Sunset Cliff in Ocean Beach, San Diego. (Courtesy of Harlo LeBard.)

Most surfers in those days kept warm one of two ways: wine and wool. A bota bag of wine would often be hung off the pier just above the water so surfers could take swigs in between rides. More common were wool sweaters, such as this one on George Strempel. Strempel is riding South Side in 1948 on his balsa redwood. (Courtesy of George Strempel.)

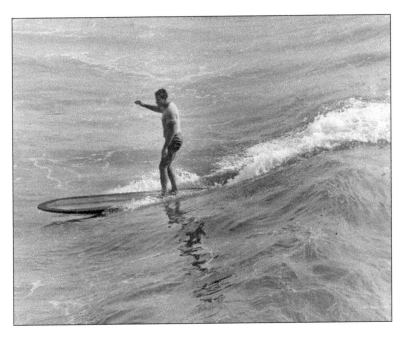

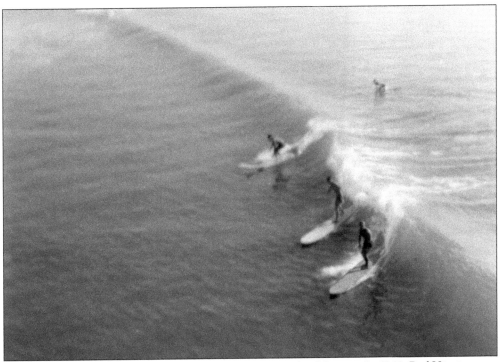

Harlo LeBard captured this shot of a group of surfers south of the pier. In 1948, Bud Higgins gave LeBard, Rocky Freeman, George Strempel, and their fellow surfer friends permission to commandeer a room under the pier to store their boards. Everyone got keys, and Freeman made a sign lettered in rope inside reading "Keoki" — Huntington Beach's first surf club. (Courtesy of Harlo Lebard.)

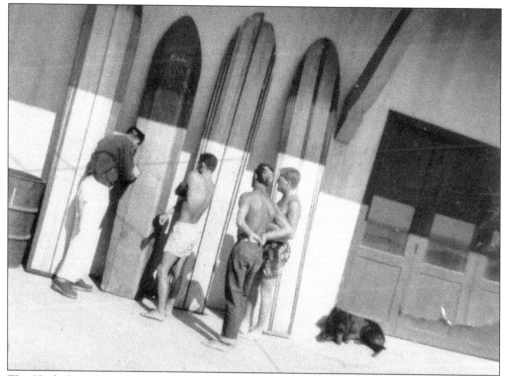

The Keoki board room was named after Rocky Freeman's dog, who was named after George Strempel. ("Keoki" is "George" in Hawaiian.) Core members included Strempel, Freeman, LeBard, Dean Ashbrook, Bud Swift, Bob Hoyt, Joe Riddick, and Bob Knisley. Here, Knisley (far left), Freeman (in jeans), and several others inspect a black board Freeman shaped from balsa life rafts around 1949. Joining them is possibly Keoki the dog. (Courtesy of Jeri Macres.)

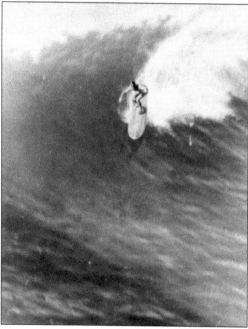

The Keoki board room lasted roughly three years until the town got suspicious about what was going on under their pier and took back the room. In the end, the Keoki was less a formalized club than a bunch of guys hanging around with surfboards. But unknowingly, this young group of surfer friends had just kicked open the Golden Age of Surfing in Huntington Beach. Heralding the moment, Rocky Freeman flies toward the pier. (Courtesy of Jeri Macres.)

Three

SURF BOOM
1950–1966

Freeth and Duke introduced surfing to Huntington Beach, Bud and Gene made it a local pastime, and the Keoki Club turned it into an institution, but it wasn't until the next generation came together that it really took off.

Thanks to a combination of baby boomers, postwar technology, the popularity of *Gidget*, and the Beach Boys' "Good Vibrations," surfing gained newfound acceptance amongst the masses during an explosive "surf boom." Prior to this wave-fueled explosion, it was estimated the country's dedicated surfing population was a few thousand. By the mid-1960s, there were said to be as many as half a million "surfers" across the country. The real deal could be found hanging around the HB pier.

One of the biggest boosts to surfing during this time was the invention of the foam board, which changed the game with its lightweight, easily-streamlined design. But even before the shift from balsa wood to polyurethane foam, a new era in surfing was starting to bubble over. Since Huntington Beach was centrally located to this growing wave-crazed population, the pier became a meeting point for hardcore surf rats. These were the dudes that grew Huntington Beach into a surf community. These were the surfers that surfed not because it was a fad but because it was a lifestyle.

While HB certainly played a part in the growing mainstream fervor that would sweep the nation, its own more localized version of the surf boom would have a far greater lasting legacy.

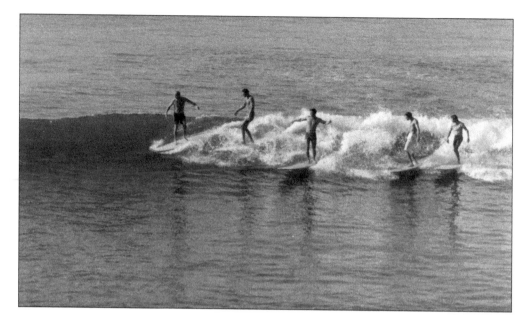

This February 1956 shot captures a moment from the Golden Age of Surfing in Huntington Beach. Note the distinctive style of each surfer. In the early days of surfing, one did not have to see someone's face to tell who was riding a wave. Most had a unique stance that was instantly recognizable. Like the guy in the middle, Dick "Iron Legs" Thomas, so named because he could power through anything without ever falling off. On the far right in a wool sweater is Rocky Freeman. Far left (in both images) is very likely Orral "Blackie" August, father figure and surf guru to local gremmies. Blackie's son Robert would help close out the era on a high note when he starred in *The Endless Summer*. Below, some of this same group surfs another session during a "crowded" day by the pier. Fortunately for them, the surf boom had yet to reach the masses. (Courtesy of Harlo LeBard.)

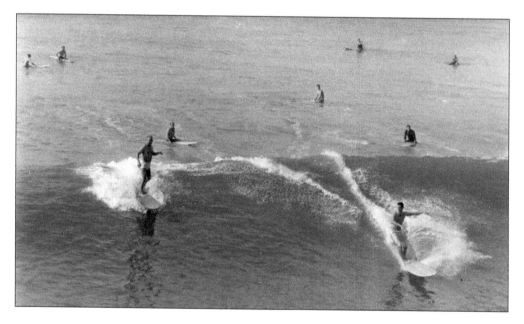

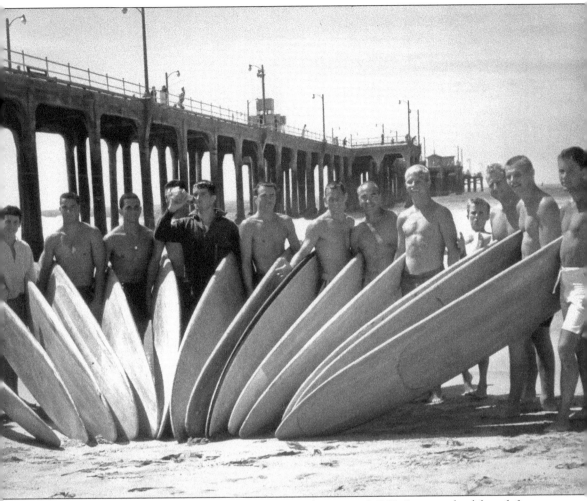

Some of HB's wave-riding trailblazers take a group shot around 1955. Starting third from left to right are Chuck Linnen, possibly Dick Thomas (hidden behind Lloyd Murray's bottle), Lloyd Murray, Del Cannon, Pete Siracusa, Blackie August, Gus Gustafson, Willie Lenehan (young boy), Dave Francey, Richard Byyny, and John Gray. This image comes from the archives of Bruce Brown, famed filmmaker of *The Endless Summer*. It was likely taken by Bruce, who was a regular by their pier during this time, or his associate Bob Bagley, who also took the photograph used for *The Endless Summer*'s iconic poster (see page 51). While Bruce Brown's classic film would cap off the surf boom, these legends are the ones that helped it start. Many would later be inducted into the Surfing Walk of Fame as part of the "HB Boys of '55," which honored the group of beachgoers who made Huntington Beach a surf city long before anyone recognized it as such. (Courtesy of Bruce Brown Films, LLC © 1964, 2018.)

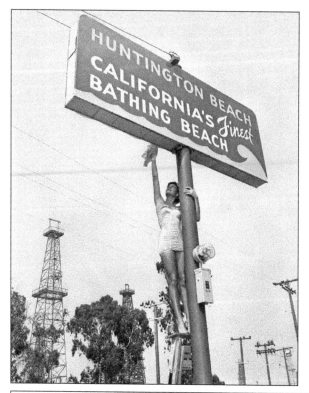

Surfers were not the only ones riding into a new era. While HB would never stop producing oil, ocean-side housing and recreation slowly began to take precedence. Seventeen-year-old Carole Cuff helps make the point with this sign in 1952. (Courtesy of the Orange County Archives.)

Lloyd Murray (left), Gordon "Gordie" Duane, and Pete Siracusa take a photograph the same day as the one on the previous page. Pete was born in HB and taught to surf by Rocky Freeman on the black "Pohaku"-inscribed board (Hawaiian for "rock") on page 28. Gordie fell in love with surfing while in the Navy stationed in Hawaii. In 1956, he moved to HB and opened its first storefront surf shop. (Author's collection.)

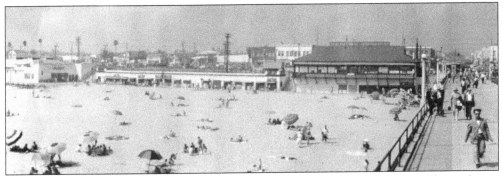

Gordie Duane's surf shop was located North Side directly next to the Saltwater Plunge. It was comprised of four garage-like rooms (for glassing, shaping, storage, and display) and rented for $10 a month along a row of concessionaires on the beach. This photograph shows where HB's first surf shop was located, right beside the stairs before the Plunge. (Courtesy of the City of HB Archives.)

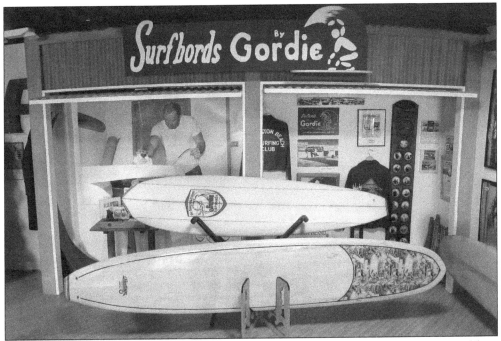

Gordie Duane enlisted Knott's Berry Farm art director Don Treece to design a sign and logo befitting his beachfront shop. The result was "Bubble Man." The only problem was Treece misspelled surfboards. Duane's response was "we're surfers, not spellers." This display at HB's International Surfing Museum partially recreates the garage exterior of Duane's original shop, misspelling and all. (Author's collection.)

The one and only Chuck Linnen surfs North Side in 1958. Early on, Gordie Duane partnered for a short time with former Keoki member George Strempel, who contributed his board-shaping acumen. One of the boards Strempel made while working with Duane was the balsa "pig" Linnen rides here. (Courtesy of George Strempel.)

Roy Crump (center) surfs near the pier with several others, including Ray Luchini and Steve Young. In the back, Chuck Linnen looks on. Crump started surfing in 1949 and has probably competed in as many HB contests as anyone, spanning over five decades. He was also an early surfing pioneer of Hawaii's North Shore. (Photograph by Chuck Morrel, courtesy of Roy Crump.)

The "Barrymore Boys"—Tom "Kamikaze" Gibbons, Dean Kahl, Dave "Keoki" Burris, Dwayne Davis, and Lee "Sharky" Willmore—pose around 1958 with their nine-foot, six-inch balsa board shaped by Dick Barrymore. These Huntington Beach High School friends worked nights at Sam's Seafood Restaurant in Sunset Beach so they could surf during the day, sharing the board between them. (Courtesy of Tom Gibbons.)

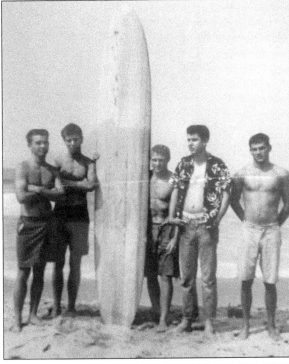

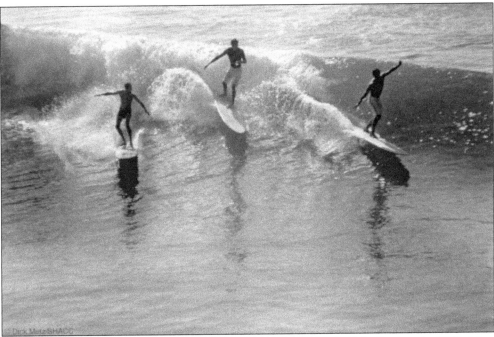

From left, Dick Metz, Harold Walker, and Dick Thomas surf South Side. During the 1950s, Metz ran a Huntington Beach liquor store called Surf Liquors. In 1958, not long after this session, he departed on a three-year worldwide hitchhiking excursion, helped paid for by selling his liquor licence to Disneyland. Metz's time wandering the globe later inspired friend Bruce Brown to make *The Endless Summer*. (Photo courtesy of Dick Metz/SHACC.org.)

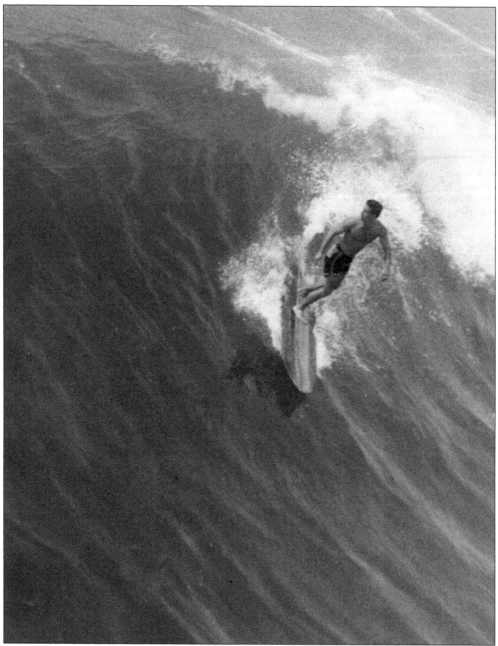

Don Stewart rides North Side during the late 1950s. Stewart was a career lifeguard who got his start in HB and later became an accomplished sculptor, woodworker, and taxidermist. He started surfing in 1955 and learned fiberglassing from legendary shapers like Gordie Duane. Using the combination of these unique skills, he crafted aquatic sculptures and vintage surfboards. Most famously, he made Dick Metz a board to repay all the liquor and sandwiches he and friends "borrowed" over the years from Metz's store when they were younger. (Courtesy of Erin McNally.)

In 1959, Gordie Duane's shop caught fire. Close to shutting down for good, friends encouraged him to rent an old oil well welding shop at PCH and Thirteenth Street. This 1960 receipt for a custom board was one of the first to come out of the new shop. It was paid by Chris Cattel for $124.28. By then, Don Treece had redesigned Duane's logo into the now famous shield with a free-spirited surfer catching a wave. (Courtesy of Chris Cattel.)

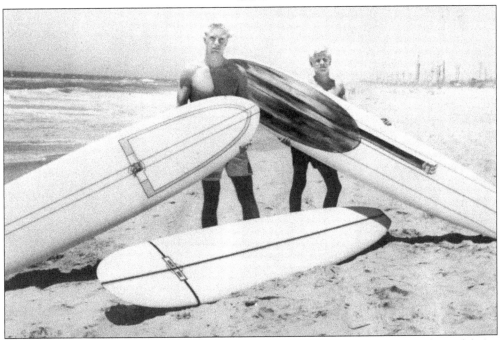

Two young surfers pose with Gordie surfboards, each holding his famous "Lizard" model. An expert craftsman, Gordie Duane created some of the most advanced designs of the time. When balsa gave way to foam, he was an early adopter, notably becoming the first to incorporate a "stringer." This thin strip of wood down a foam board's center adds strength and rigidity and is today fundamental to surfboard design. (Courtesy of the City of HB Archives.)

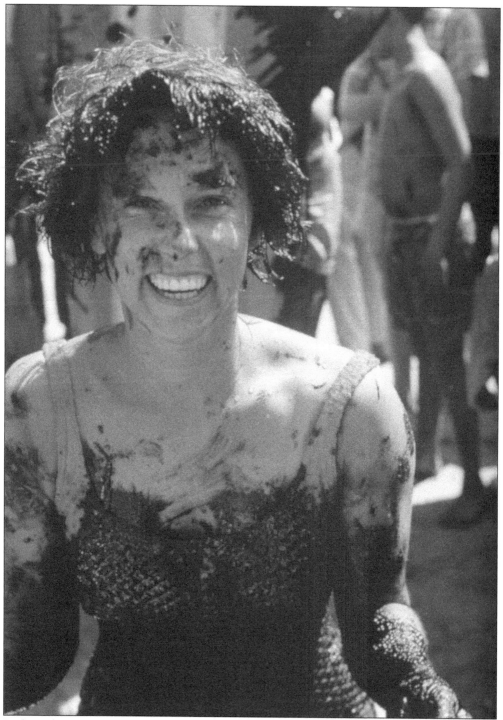

In the early 1960s, an oil tanker collision offshore caused a large spill during a tandem surf event by the pier. The riders went out regardless and came back covered in oil. Though as first place finisher Patti Carey shows, they didn't let it ruin their stoke. (Photo by Carl Wilcke; courtesy of Ingo Wilcke and Randy Nauert.)

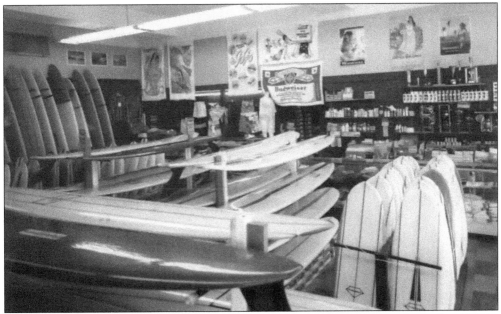

Huntington Beach's second storefront surf shop was Jack's Surfboards. It was opened in 1957 by Jack Hokanson, who saw a need for a full-service store after witnessing his son get out of the water following a surf session literally blue in the face from cold. The result was a one-stop surf shop selling wetsuits, clothing, and boards, as seen here in this mid-1960s interior photograph. (Courtesy of the City of HB Archives.)

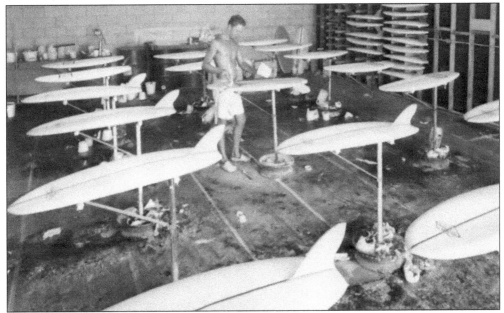

A glosser puts the finishing touches on a Jack's kneeboard. Jack's Surfboards first opened across the street from where it is today (currently Huntington Surf & Sport). In the early 1960s, it moved to the old Rexall drugstore brick building opposite. Right from the start, Jack's was as big an operation as any surf shop in the area, creating all kinds of boards, including skateboards. (Courtesy of the City of HB Archives.)

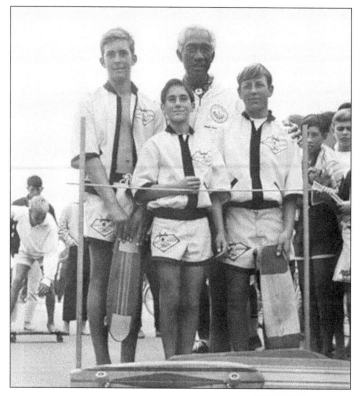

Jack's was one of the first to market "sidewalk surfing," building skateboards resembling small surfboards and starting an exhibition team in the early 1960s. During a return visit, Duke Kahanamoku took this shot with Jack's team riders; from left to right are Randy Lewis, Mickey Maga, and Dennis Klepfer. (Courtesy of Randy Lewis.)

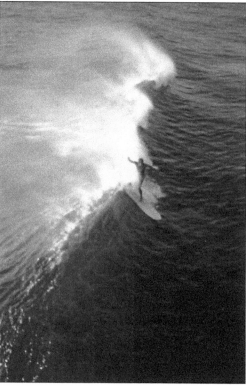

Local surfer Lee Willmore captured this shot of an unidentified, lone "regularfooter" (someone who surfs with their left foot forward) heading toward the pier in 1959. Notice the spray coming off the lip of the wave, indicating a nice offshore wind. This causes a slower and cleaner break, creating an ideal condition for catching a wave. (Courtesy of Lee Willmore.)

How far surf reports have come. Lifeguard Harold Lewis (stepson of Keoki member Harlo LeBard) gives a family the forecast, aided by this public weatherboard located outside lifeguard headquarters in 1960. On this particular day, the surf condition was "high." (Courtesy of the City of HB Archives.)

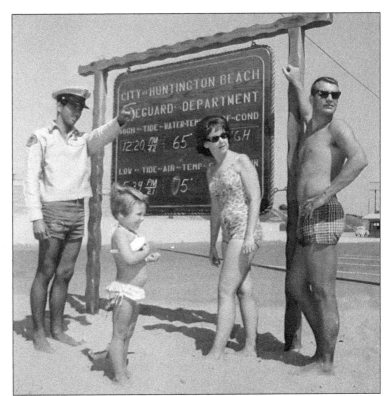

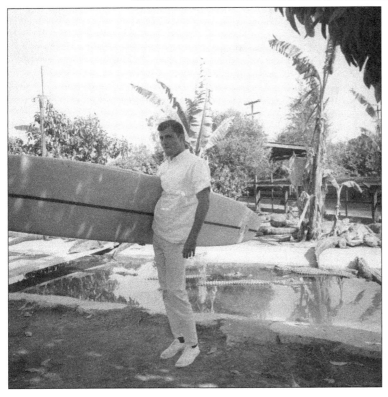

Another of HB's earliest surf shops was Holden Surfboards, started by Bill Holden in the late 1950s at 17443 Beach Boulevard. Holden's motto was "Everywhere . . . there's a Holden board." Several ads ran in surf magazines proving the point with their surfboards shown all over, from atop a skyscraper to in bed with a woman. Here, Lee Willmore poses for one such advertisement in a pit of alligators. (Courtesy of Lee Willmore.)

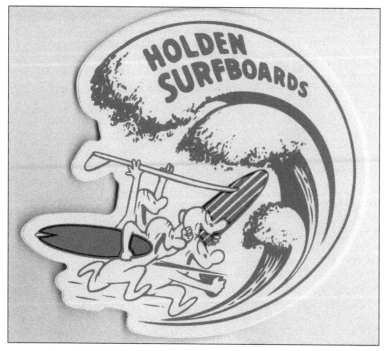

The Holden Surfboards logo shows grinning gremlins racing for the surf. Just as stoked, Bill Holden was one of the most well-liked shapers in the industry. He was lifelong friends with pioneer boardmaker Dale Velzy and helped Bob Bolen start his shaping career by selling him his first foam blank. (Courtesy of Brad Holden.)

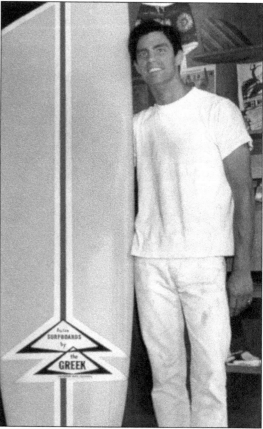

Bob "the Greek" Bolen holds a board brandishing his iconic "Custom Surfboards by the Greek" logo. A self-taught surfer and shaper, the Greek opened a shop on the PCH in 1960 and quickly became one of the top boardmakers around. His nickname came care of high school friends on account of his Greek ancestry, a moniker he later adopted for his temple of surf in Huntington Beach. (Courtesy of Bob Bolen.)

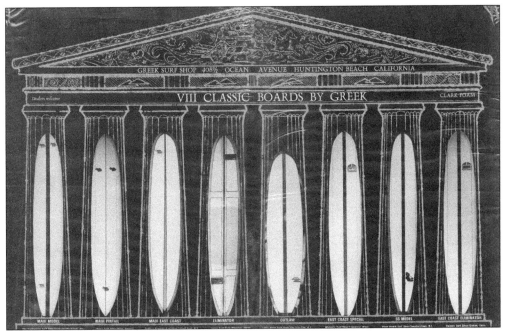

The Greek has shaped thousands of boards, designing one of the most impressive and progressive arsenals around. This mid-1960s advertisement showcases several models, including one of his best known: a high-performance noserider called the Eliminator. Note the aptly named Outlaw, a harbinger of the upcoming shortboard revolution. The surrounding structure is the Parthenon in Greece, whose top is represented by the triangles in the Greek's logo. (Courtesy of Bob Bolen.)

Surfing was not all that was booming during the 1960s. Huntington Beach consistently held the title of "Fastest Growing City in the Nation," increasing from around 11,000 residents at decade's start to over 110,000 by its end. This billboard shows HB's suburban dreams realized. Route 39 (Beach Boulevard) where it stood is a far cry from today, with empty bean fields behind it. (Courtesy of the Orange County Archives.)

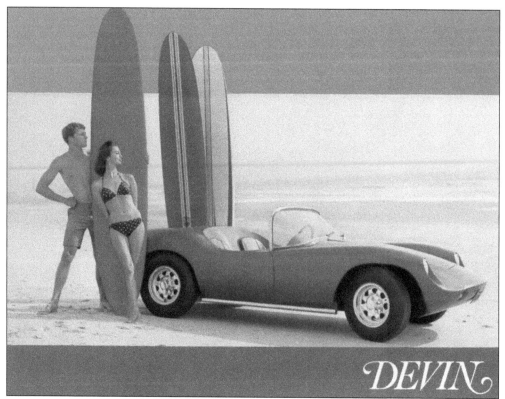

DEVIN

One day, John "Frog" Van Oeffelen walked into Gordie Duane's shop. Next thing he knew, he was being enlisted by Duane for a photo shoot with a car company. This advertisement was the result, depicting Frog gazing at the surf with an unidentified model, three Gordie's, and red fiberglass Devin C Type—just another day at the beach. (Courtesy of Devin.)

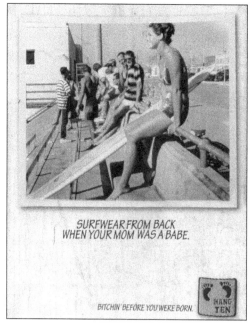

SURFWEAR FROM BACK
WHEN YOUR MOM WAS A BABE.

BITCHIN' BEFORE YOU WERE BORN.

Surf industry pioneer Duke Boyd took this early-1960s photograph atop South Side's bleachers (since torn down). It later appeared in a 1990s throwback advertisement for Hang Ten. Originally, Boyd only wanted Anne Harrington and the board, but the guys were too busy hanging out to move, so they became Hang Ten models. From right to left, they include Rocky Freeman and Pete Siracusa (looking at camera), Mike O'Day (wearing sunglasses), Chuck Dent (in white shirt), Gordie Duane and Ron Stewart (behind Dent), Roger Wilde (shirtless), and Robert August (in white striped shirt). (Courtesy of American Brand Holdings, LLC.)

Jan Gaffney joins lifeguard Russ Webb in 1960 as he waxes a Gordie surfboard. Gaffney was one of the first female surf stars in the area and would later have a major influence on the HB surf scene when she opened her health food bar on Main Street. (Courtesy of Chris Cattel.)

A 12-year-old Barry Church (center) is joined by siblings Al and Judith for a fun day at the beach in 1960. The board is an early foam design. Notice the surf mats, which reached their peak in popularity during this time. Church became a charter member of the Huntington Beach Surfing Association and, by decade's end, was a top-ranked competitor and lauded surfing photojournalist. (Courtesy of Barry Church.)

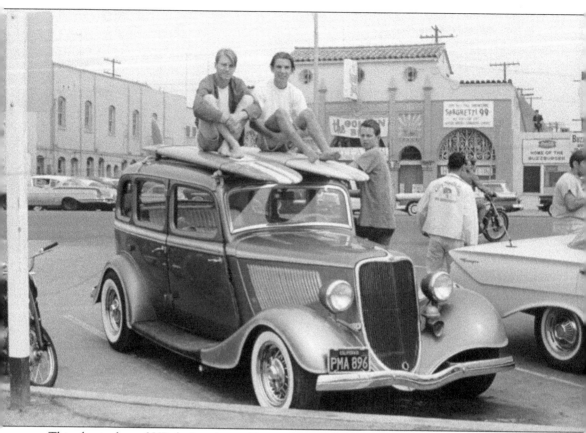

This classic shot of HB during the surf boom was taken around 1961 by "the godfather of surf photography," LeRoy Grannis. These young surfers sit atop longboards on a 1933 Ford. Behind stands the iconic Golden Bear. Opened during the 1920s, this one-time small cafe turned restaurant hotspot had by the 1960s become one of Southern California's most popular music venues. Over the years, it hosted some of the best acts anywhere, including Janis Joplin, Jerry Garcia, Muddy Waters, Jimi Hendrix, the Doors, B.B. King, John Denver, Robin Williams, Steve Martin, and Charles Bukowski, as well as surf musicians like Dick Dale and Jan and Dean. On this date, it featured folk singer Hoyt Axton and 99¢ all-you-can-eat spaghetti. To the right is the Buzz Inn, which fueled many a surf session during this era with surfers grabbing a cheap bite, hanging out, watching the waves in the morning, and returning again in the afternoon. (© LeRoy Grannis Collection, LLC, courtesy of M+B, Los Angeles.)

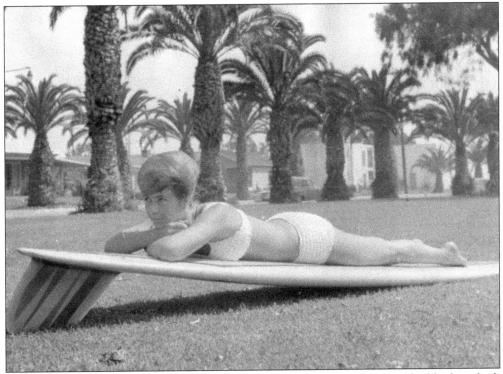

Dawn Majors poses in Lake Park. The longboard she lies on sports a large, rudder-like fin, which was an industry standard between 1958 to 1966 and practically tailor-made to make it easier for *Gidget*-inspired beginners to learn to surf, while also providing longer noserides for experienced riders. Apparently, it also made for nice photo shoots on grass. (Courtesy of the City of HB Archives.)

At a time when female surfers were few and far between, Duline McGough showed how it was done surfing South Side in November 1963. A consummate surfer and paddleboarder, during the 1960s McGough was a member of Gordie's exhibition team (see page 64) and regularly competed in contests by the pier—one year, taking home the women's Huntington Beach resident trophy. (Photograph by Jim Driver, courtesy of Duline McGough.)

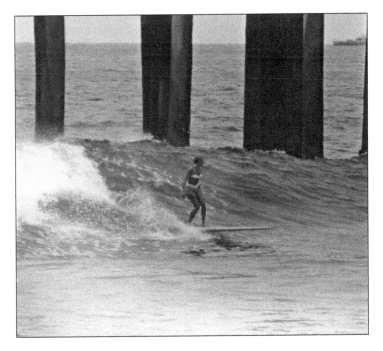

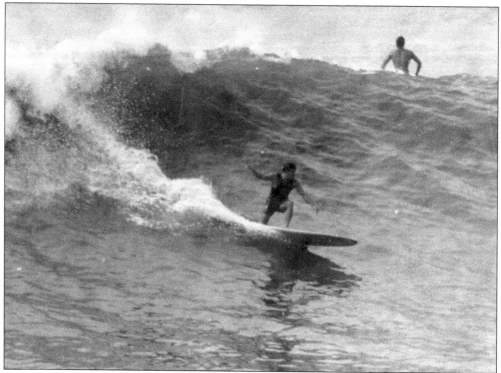

Duline's close friend and one-time tandem partner, Lee Willmore surfs North Side in the early 1960s. Lee was a talented fixture of the HB surf scene who got his start as one of the "Barrymore Boys." The surfer behind him is Dick Brewer, who would go onto become one of the most influential shapers of all time, notably having his first custom board made by Gordie Duane. (Courtesy of Lee Willmore.)

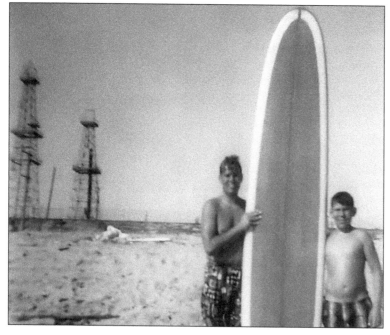

John LaRoche (left) and brother Jody share a Scholl-designed surfboard in 1962 near Seventeenth Street. Joel "Jody" Mitchell LaRoche was later drafted into the Army and, in August 1968, killed in action in Vietnam. He is remembered today at a memorial outside city hall along with all of Huntington Beach's residents lost serving their country. (Courtesy of John LaRoche.)

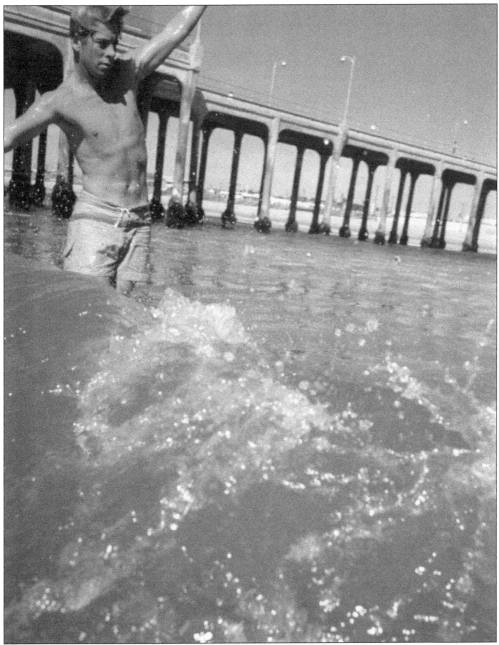

Bill Fury rides South Side in this image captured by iconic surf photographer Ron Stoner in 1965. Fury epitomized the free surfer, someone who does not ride for fame, money, or contests, but paddles out for the pure fun of surfing. Fittingly, he later appeared in the classic surf film *Free and Easy* doing just that. He also appeared in a famous painting by Laguna Beach artist Ken Auster, which was based off another Ron Stoner photo. It featured Fury hanging ten on an endless wave in Mexico as friend (and HB pier regular) Tom Leonardo paddles out in the foreground, pumping his fists in stoke. It is a perfect moment showcasing surfing at its purest, something that Bill Fury embodied every time he took to the water, with a graceful style and uncanny noseriding ability that turned wave-riding into an art form. (© Ron Stoner/SURFER Mag/SHACC.)

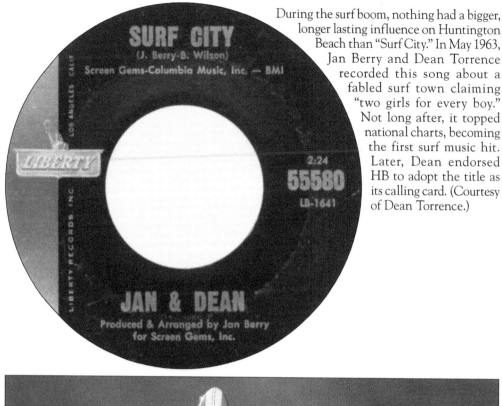

During the surf boom, nothing had a bigger, longer lasting influence on Huntington Beach than "Surf City." In May 1963, Jan Berry and Dean Torrence recorded this song about a fabled surf town claiming "two girls for every boy." Not long after, it topped national charts, becoming the first surf music hit. Later, Dean endorsed HB to adopt the title as its calling card. (Courtesy of Dean Torrence.)

The first draft of "Surf City" was written by Beach Boy Brian Wilson under the working name "Goody Connie Won't You Come Home." Luckily, the title was changed when he offered it to Jan and Dean, who turned it into the song known and loved today. Through memorable songs like "Surf City," they helped pioneer the California sound and transform the local beach lifestyle into an American ideal. (Courtesy of Dean Torrence.)

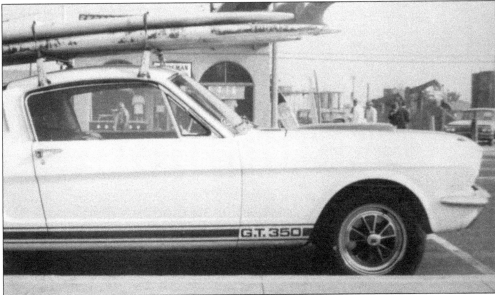

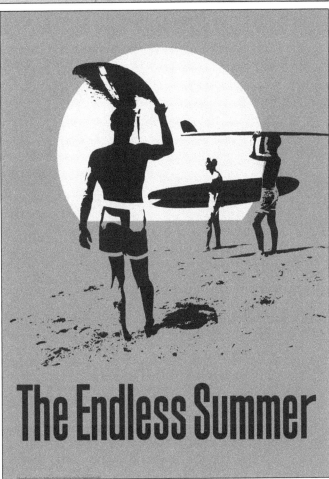

A Shelby Mustang GT350 "surf wagon" sits in front of Vardeman Surfboards around 1966. In 1962, Sonny Vardeman opened his shop near Third Street on the PCH and employed famed boardmaker Bruce Jones, who shaped iconic longboards in the backroom for local HB surfing hero Jackie Baxter. The Shelby is all set to embark on a surf trek in style, undoubtedly inspired by *The Endless Summer*. (Author's collection.)

Filmmaker Bruce Brown's *The Endless Summer* is the culmination of the surf boom. It brought surf culture into the mainstream while still retaining surfing's essential spirit. It was screened often to local delight at HB's Surf Theatre on Fifth Street surrounding its initial release in 1964 and worldwide premiere in 1966. (Courtesy of Bruce Brown Films, LLC © 1964, 2018.)

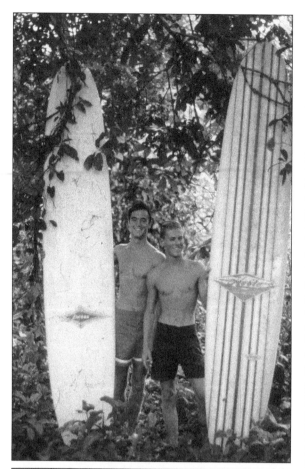

The Endless Summer was a narrative documentary following two surfers on an around-the-world adventure in search of surfing's holy grail, the "Perfect Wave." It stars Robert August (left) and Mike Hynson, seen here trekking through a Nigerian jungle. Below, August surfs in *The Endless Summer*. In 1963, he had just graduated from Huntington Beach High School and was preparing to become a dentist. Bruce Brown called and asked if he would like to make a surf-travel film. Seven months later, August returned, and dentistry was out. Brown later said he chose August because he represented surfing in a positive light. A natural "goofyfooter" (someone that surfs with their right foot forward) and local hero who grew up surfing the pier and hanging around the South Side bleachers, Robert August is a true icon of surfing and one of the best the surf boom had to offer. (Both photographs, courtesy of Bruce Brown Films, LLC © 1964, 2018.)

Four

THE CONTESTS
1959–1966

According to Bud Higgins, the first ever surfing contest in Huntington Beach was held in 1933. It was sponsored by the HB lifeguards during a day of big surf and won by Dave Beall of Santa Ana.

Modern-day competition began in 1928 at Corona Del Mar, fusing paddleboarding and surfing into a one-off race out to a buoy and back again. (It was won by Tom Blake.) In 1938, the format was revised to a point-based system, with one point earned for each ride that lasted a specified length. Over the next two years, the National Surfing and Paddleboard Championships were held in Long Beach. Surf clubs from across California and Hawaii competed. Since HB did not have a formal club at that point, it did not enter, though a few locals likely participated as part of the Long Beach Surf Club.

In the beginning, there was no prize money, and no one really cared about trophies. If the surf was up, contestants continued surfing long after the contest ended. Competitions were just another way to have fun, see what the other guy was doing, and gain some bragging rights for your club.

By the 1960s, things had changed. Beach cities were enacting anti-surfing regulations to combat overcrowding and the "unsavory behavior" of teenage surfers. Realizing the sport might be in trouble, there was a push to show surfing was more than beach bums goofing off in the sun and to provide a better platform to showcase its talents.

The original concept to create a bigger and better surf contest in California came from Cal State Long Beach student Peter Beltran. Joined by surfing notables including Lorin Harrison, Hobie Alter, and Gordie Duane, he presented the idea to HB director of recreation Norman Worthy. Thus, the West Coast Surfboard Championships were born.

The rest is competitive surfing history.

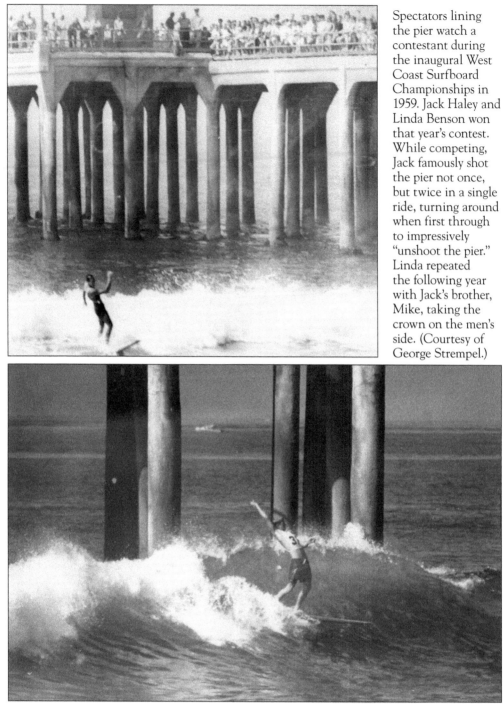

Spectators lining the pier watch a contestant during the inaugural West Coast Surfboard Championships in 1959. Jack Haley and Linda Benson won that year's contest. While competing, Jack famously shot the pier not once, but twice in a single ride, turning around when first through to impressively "unshoot the pier." Linda repeated the following year with Jack's brother, Mike, taking the crown on the men's side. (Courtesy of George Strempel.)

Sixteen-year-old Laguna Beach surfer Ron Sizemore steals the show in 1961 with some impressive dexterity to win the third West Coast Surfboard Championships. Deploying every trick in the book, Sizemore pulled off stance switches, spinners (spinning in a circle on the board), shooting the pier standing backward, and anything else he could think to defeat top riders of the day. (Photograph by Richard Scotty, courtesy of Roy Crump.)

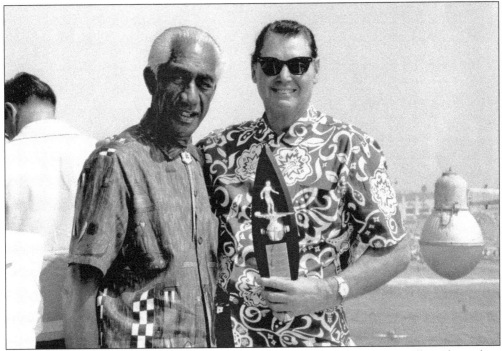

In 1963, Duke Kahanamoku cohosted the championships with Johnny Weissmuller. Johnny, best known as *Tarzan*, holds an award for his "distinguished contributions to the sport of surfing." Two of the most prolific watermen of the 20th century, Weissmuller broke Duke's record in the 100-meter freestyle during the 1922 Olympics. Over the next five years, Duke would be the guest of honor at HB's contests. (Courtesy of the City of HB Archives.)

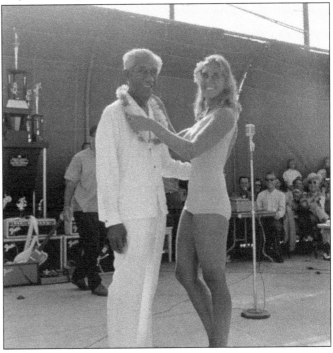

Duke Kahanamoku is joined by Candy Calhoun during the awards ceremony for the 1963 championships. Candy is the daughter of women's surfing pioneer Marge Calhoun and an amazing surfer in her own right. She won that year's event and served as "Surf Queen," whose role amongst other things was to help present the awards to the winners—so, in this case, herself. (Courtesy of Ron Church Photography, donated by Tani Church.)

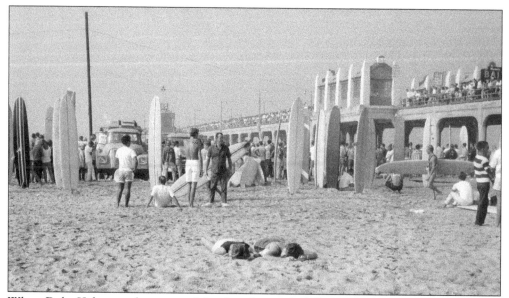

When Duke Kahanamoku returned, he found a much different (and far more crowded) surf scene than the one he helped propagate in the 1920s. The throngs of people lining the pier with prime viewing in the 1963 photograph above shows why HB was the perfect spot to host the championships. Below, beachgoers mingle in front of the Pav-A-Lon. The press release for that year's contest listed three bands set to play the ballroom on September 21st: the Dartells, the Surf Bunnies, and "the Pendeltons"; very likely, the last is a misspelling of "Pendletones." A play on words, this was what the Beach Boys originally called themselves, named after the Pendleton wool sweaters surfers often wore. (Both photographs, courtesy of the City of HB Archives.)

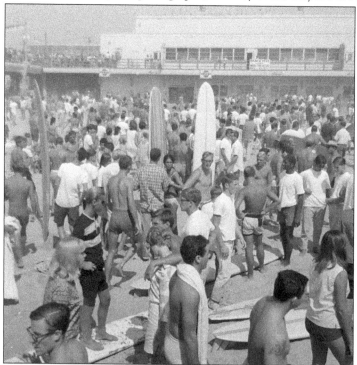

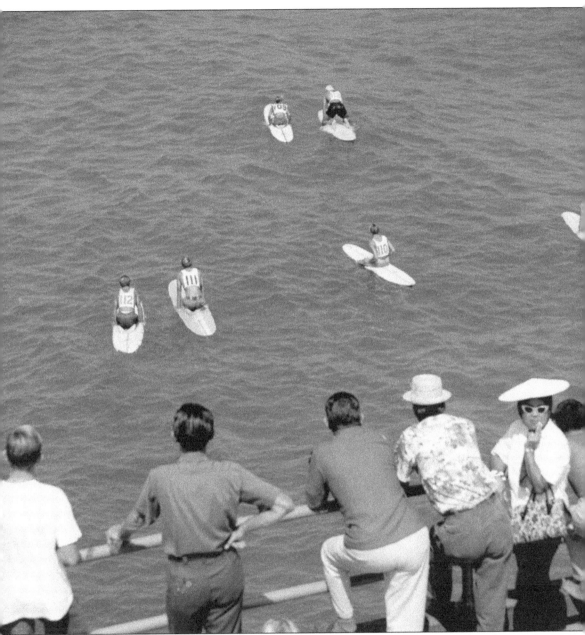

No photographer better captured HB's surf contests than Ron Church. An entire book aptly named *Surf Contests* compiles his evocative shots, taken over several years in the early 1960s. Church was one of the first professional photographers to take an interest in surfing, becoming a cult surf documentarian with his iconic black-and-white photos. Many of the following photographs are from his collection, included here by the gracious donation of his daughter Tani. (Courtesy of Ron Church Photography, donated by Tani Church.)

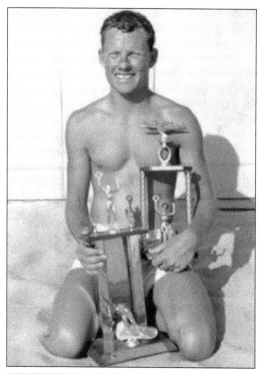

Corky Carroll poses with his trophies from the 1963 West Coast Surfboard Championships. A fun-loving goofyfooter hailing from nearby Surfside, Corky is recognized as the first professional surfer. He first competed at age 11 during the contest's inception in 1959, leading to a prolific career that included being voted the best surfer in the world by his peers in 1968. (Courtesy of Ron Church Photography, donated by Tani Church.)

Surfers watch a heat at a nearby contest in Oceanside. Sitting center in the Hawaiian shirt and wool hat is Corky Carroll. To the far right is a young David Nuuhiwa. Born in Hawaii and eventually settling in HB, Nuuhiwa was an up-and-coming surfing sensation who would soon win back-to-back junior's division titles in 1965 and 1966. (Courtesy of Ron Church Photography, donated by Tani Church.)

These early contests were small by today's standards, but they still had a good number of people in attendance. Fortunately, longboards were not just for surfing; they also made for a great lookout perch for anyone adept enough to get up on one. (Courtesy of Ron Church Photography, donated by Tani Church.)

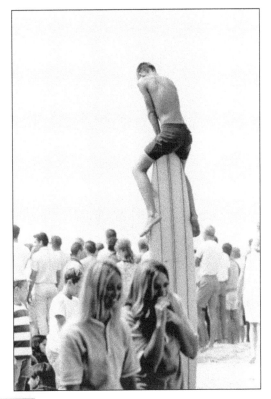

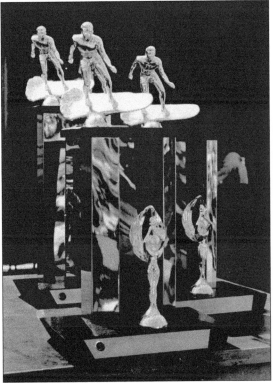

Trophies wait to be awarded to the winners of the 1963 West Coast Surfboard Championships. The contest's main event was the "Freestyle Surfboard Riding Contest," scored on a 1-10 point system. Results were based on wave judgment, take-off, maneuvering, sliding ability, and pullout. Upgrades were given to tricks such as head dips and spinners. Shooting the pier did not increase a score, supposedly. (Courtesy of the City of HB Archives.)

Huntington Beach's surf contests have always been a venue for more than just surfing. Here, the Challengers perform before a massive crowd during the 1963 championships. From left to right are Don Landis, Glenn Grey, and Randy Nauert. The group's debut released earlier that year, *Surfbeat,* remains the best-selling instrumental surf album of all-time. Thanks to surf rockers like the Challengers, the wet sounding reverb coming off Dick Dale's guitar, and the harmonized vocals of the Beach Boys and Jan and Dean, surf music was, and still is, one of the most endearing aspects of surf culture. HB's contests provided the perfect opportunity for these entertainers to delight their fans and often draw crowds as big as the contest itself. (Courtesy of Ron Church Photography, donated by Tani Church.)

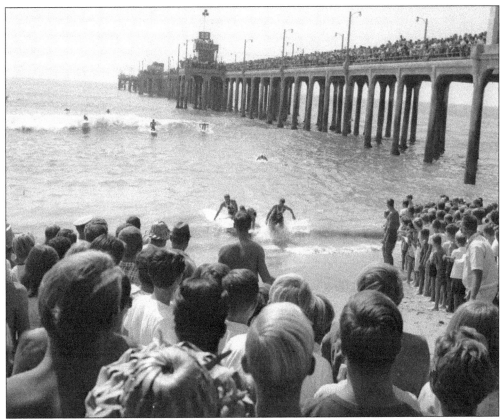

The first contest in 1959 was relatively small, with five divisions and 75 entrants. By 1968, the number of events had doubled and included 500 competitors. Here, around 1964, contestants compete in one of the contest's most exciting divisions, the around-the-pier paddle race. The winner was whoever first carried their board across a finish line up on shore. (Courtesy of the City of HB Archives.)

By 1964, the contest was attracting wave-riders from across the country and was renamed the United States Surfboard Championships (USSC). This rare official program for it features Anne Harrington, that year's Surf Queen. The title of Surf Queen (or "Miss Surfboard") was often bestowed upon talented female surfers competing in the championships. (Author's collection.)

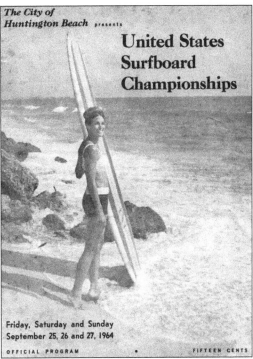

The City of
Huntington Beach presents

United States Surfboard Championships

Friday, Saturday and Sunday
September 25, 26 and 27, 1964

OFFICIAL PROGRAM · FIFTEEN CENTS

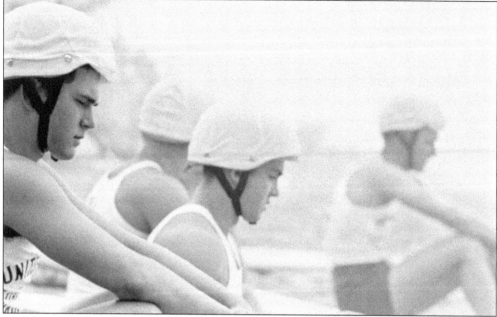

A group of young wave-riders prepares for their heat at the 1964 US Surfboard Championships. This was the first year the City of Huntington Beach required contestants wear helmets. Most were not fans of the cumbersome headgear, though the best certainly did not let it impede their surfing. (Courtesy of Ron Church Photography, donated by Tani Church.)

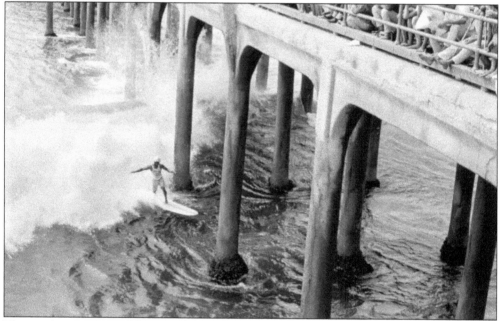

The gnarly experience of shooting the pier has always been a highlight of HB, for both spectators and surfers. One minute, someone is zipping along on a nice left, and in the next, they are flying board first into razor-sharp, barnacle-encrusted cement pilings. For those that do not pull out like this competitor, the feat is a crowd-rousing badge of honor. (Courtesy of Ron Church Photography, donated by Tani Church.)

As the contest grew, so did its coverage. Starting in 1964, the championships were broadcast for several years on ABC's *Wide World of Sports*. Here, an intrepid sideline reporter interviews Joyce Hoffman. Hoffman was one of the best, and most famous, surfers during the 60s, winning three consecutive USSC titles starting in 1965 and a fourth in 1970. (Courtesy of Ron Church Photography, donated by Tani Church.)

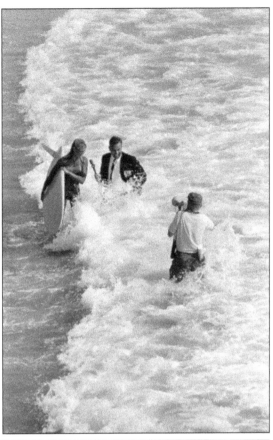

ABC's telecasts went a long way toward bolstering surfing's image in the mainstream. They treated surfers like any other athlete, and the footage they captured for *Wide World of Sports* was first-rate, made possible by apparatus like this aerial cage hanging from the pier. One year, their coverage of the contest even won top honors at the Cannes Film Festival. (Courtesy of Ron Church Photography, donated by Tani Church.)

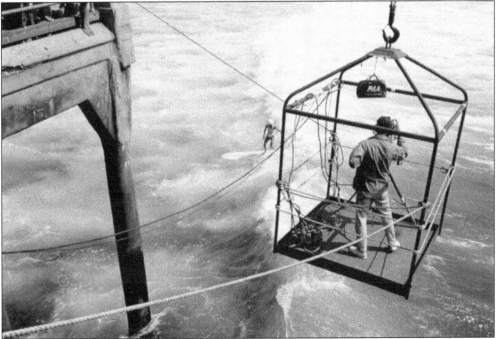

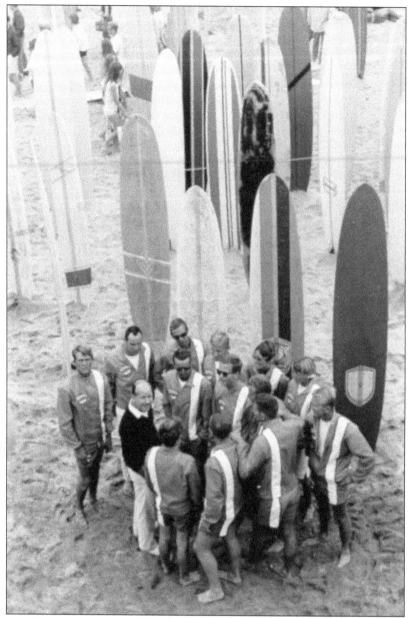

Surfing in the Olympics has been a dream as far back as the 1920s, when Duke Kahanamoku pushed to have it included. Gordie Duane shared this vision when he formed this surf team in the mid-1960s. From left to right are (first row) Bobby Leonardo, Mike Tovatt, Richard Scott, and Willie Linehan; (second row) Catalina Swimwear president Chuck Trowbridge, Chris Cattel, Danny Linehan, and Chuck Burgess; (third row) John "Frog" Van Oeffelen (looking at camera), Duane, Rich Chew, Mike Clary, Linda Skinner, and Duline McGough. At the time, Olympic surfing seemed like it could happen any moment. Since athletes had to be unpaid amateurs, Duane's group entered contests as an "exhibition team," with all equipment donated, including their specially embroidered jackets from Catalina. Unfortunately, Duane's exhibition team never got their chance at gold. It would be another 70-plus years before Duke's dreams were realized. (Courtesy of Ron Church Photography, donated by Tani Church.)

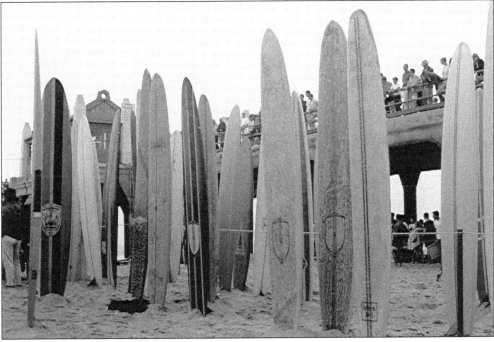

Surfboards await their heats. Many of these belong to Gordie's exhibition team members, which were distinguishable by the "naked" Gordie Surfboards' logo with an empty shield. The lone exception was Bobby Leonardo's board, far left, which he requested keep the full logo. (Courtesy of Ron Church Photography, donated by Tani Church.)

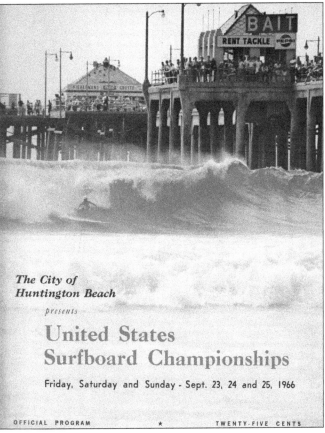

The City of Huntington Beach

presents

United States Surfboard Championships

Friday, Saturday and Sunday - Sept. 23, 24 and 25, 1966

OFFICIAL PROGRAM ★ TWENTY-FIVE CENTS

Santa Barbara's Steve Bigler surfs before a crowded pier on the cover of the 1966 US Surfboard Championship official program. Corky Carroll and Joyce Hoffman won the men's and women's divisions that year. However, the real star of the show was David Nuuhiwa. (Courtesy of Lee Willmore.)

David Nuuhiwa's noseride in 1966 was the pinnacle of performance at HB's surf contests. Considered by many the finest surfer of the 1960s, he is the quintessential noserider, floating at the tip of his board for impossible lengths of time. Few could hang ten (curl all ten toes over a board's front edge) with the nonchalance and skill of David. His soul arch shown here was the ride of that year's event and left older competitors relieved he was still competing as a junior. Though HB's surf contests would continue for a few more years afterward, they would never be quite as pure as during this time. Surfing was still in the heyday of the surf boom, its industry still in its infancy, and contests still intimate affairs presided over by surf royalty. Of course, that all changed once the revolution began. (© Ron Stoner/SURFER Mag/SHACC.)

Five

THE REVOLUTION
1967–1972

The shortboard revolution kicked off around 1967 after Santa Barbara native George Greenough and Australian Bob McTavish fused the techniques and design of kneeboarding with stand-up surfing. Based off their experiments, Australia's Nat Young had brazenly recently won the 1966 world championships on a self-shaped nine-foot-two-inch board dubbed "Magic Sam." Though only slightly shorter than what others were riding, it made all the difference, thanks to a specially designed Greenough tuna-tail fin and an inch less thickness, inspired by the boards McTavish was riding. Around the same time, San Diego kneeboarder Steve Lis hatched the design for a stubby, wide-backed split tail board called "the Fish." As several other subsequent pioneers joined the cause, this subversive shorter trend took off. Their collective innovations inspired an evolution, and surfing was never the same.

In a radical shift, board lengths began dropping from around 10 feet to under 7, with their weights cut by more than half. Seemingly overnight, longboards were out, and shortboards were in. When towns began implementing regulations (known as "blackball"), forcing surfers out of the water unless they were on shortened town-sanctioned appropriate length boards, it only fueled the charge. Thanks to the influence of local riders like David Nuuhiwa and forward-thinking shapers like Bob "the Greek" Bolen, HB had its own part to play in this upheaval.

The local revolution had begun.

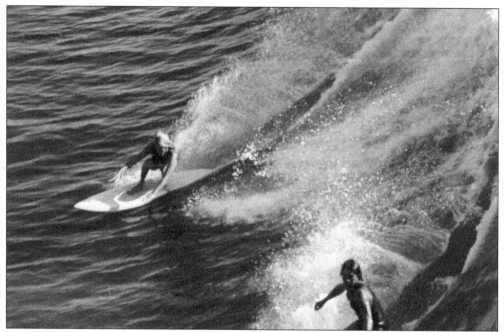

Surfing style took on a whole new meaning in the wake of the shortboard revolution as the latest generation of surfers took to the waters by the barrel full. The maneuverability and weight of shorter, thinner boards opened up the potential of HB's surf break like never before. Whereas previously bulkier and heavier longboards often sent many surfers searching for towns to the north and south with more suitable gentle, rolling waves, it was now open season on the endless swells crashing in by the pier. The crowded lineups on both sides held testament to this uprising. These images were captured on November 12, 1974. (Both photographs, courtesy of Douglas Miller.)

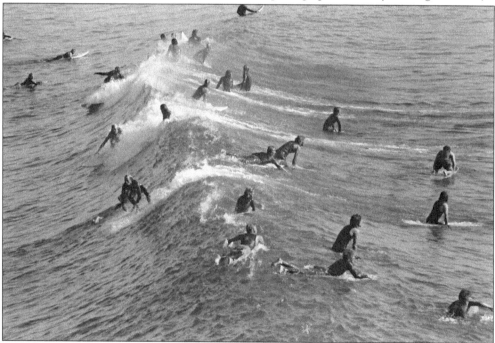

Of course, the shortboard revolution did not happen overnight, at home or abroad. In HB, early sparks began to fly when local surfers started chopping longboards in half to beat the blackball. Before that, Bob "the Greek" Bolen had already begun shortening his iconic Eliminator longboards. Then, in 1968, he released one of HB's earliest production shortboards—the six-foot-eight-inch Maui Bullet—"designed with the progressive surfer in mind." (Courtesy of Bob Bolen.)

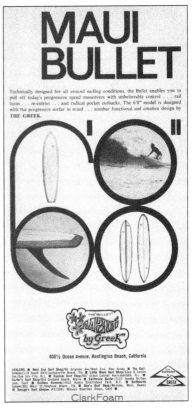

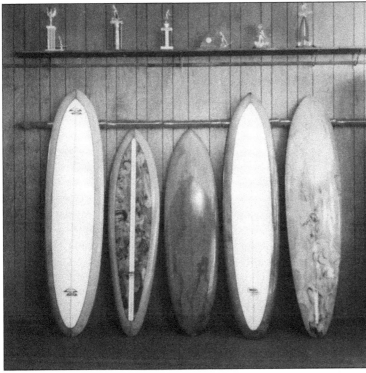

Getting in on the blackball fun, the Greek and other surf shops in town kept shaping shorter and shorter boards as the town kept dropping legal length requirements. Likewise, they had to keep lowering the height of board racks to accommodate the new, in-demand inventory, as seen here inside the Greek's shop across from the pier. (Courtesy of Bob Bolen.)

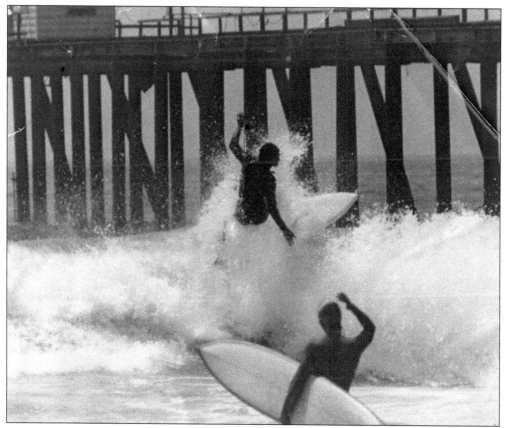

Eventually somewhere around four feet, eight inches, the town threw in the towel over the great shortboard showdown and began requiring the use of soft-top materials. But there was no looking back now. The shortboard had firmly taken root (or air) by the pier, as showcased by this rider shredding it up on a Greek-designed shortboard. (Courtesy of Bob Bolen.)

Where prior surf contest programs were clean-cut, straight-and-narrow affairs, this 1971 US Surfboard Championship program exemplifies the vibrant shift HB (and the rest of the surfing world) was experiencing during the shortboard revolution. Colorful, trippy, and a little out there, the hippie counterculture had found its way into surfing. (Courtesy of the City of HB Archives.)

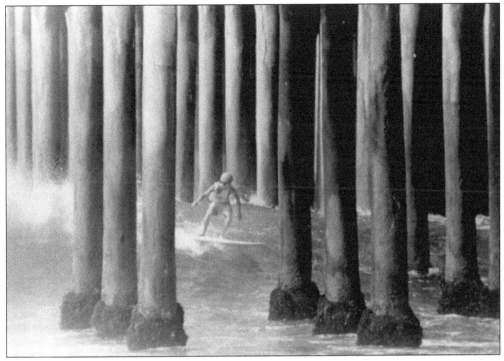

Of note in the previous page's program is the helmet worn by the rider, an odd sight, considering surfing's free-spirited break from convention during the era. Alas, as seen on this contestant shooting the pier during the 1971 USSC, the use of helmets in HB contests endured. While meant to safeguard against injuries from smashing into pilings, their clunkiness and chin strap probably made things more dangerous. (Courtesy of the City of HB Archives.)

Two of the greatest to ever surf HB look on during the 1970 USSC. Chuck Linnen (right) actually taught Corky Carroll (left) how to shoot the pier when the latter was starting out. As legendary as they come, Chuck has coached many a gremmie in the finer ways of life and pier shooting. (Courtesy of the City of HB Archives.)

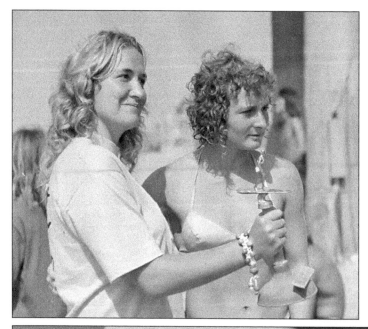

Jericho Poppler (right) takes a photograph with Liz Shelky during the 1971 USSC. Both would later become members of the Women's International Surfing Association (WISA), which Poppler cofounded in 1975 as the first all-women competitive surf organization. A US and world champion, Poppler is one the most decorated competitive surfers of all-time, winning that year's contest in HB. (Courtesy of the City of HB Archives.)

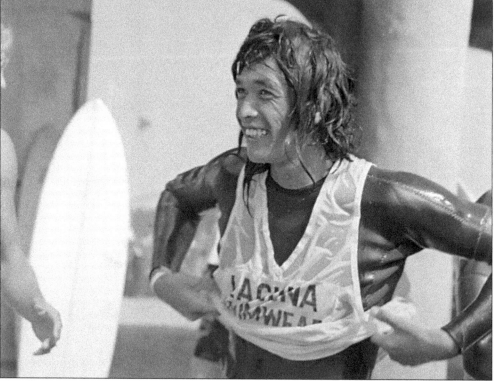

David Nuuhiwa smiles after a heat at 1971's USSC. He won that year's event. Following his sensational performance in 1966 (see page 66), Nuuhiwa found continued success. From the clean-cut noseriding 1960s to psychedelic wave-carving 1970s, he easily transitioned from longboards to shortboards. Having grown up riding little balsa boards, he later recalled, "In some ways it was like being a kid again." (Courtesy of the City of HB Archives.)

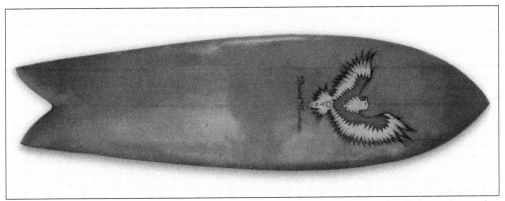

At San Diego's 1972 world championships, David Nuuhiwa showed up with a Fish similar to this six-foot model from HB's Dyno Surfboards. Locals, none too pleased with his "stealing" Steve Lis's design (see page 67), destroyed the board. Nuuhiwa placed second regardless, behind James Blears, who also rode a Fish. In many ways, the Fish culminated the revolution and this event—the good, bad, and ugly—marked a turning point. (Author's collection.)

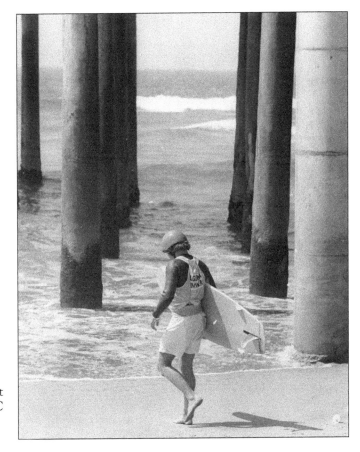

By this time, there was a growing dissatisfaction among surfers about how competitions were being managed and the difficulties of making a living as a pro. The sport's first, Corky Carroll, retired from competitive surfing at the end of 1972 at age 25. Here, he solemnly walks out during one of his last USSC appearances. (Courtesy of the City of HB Archives.)

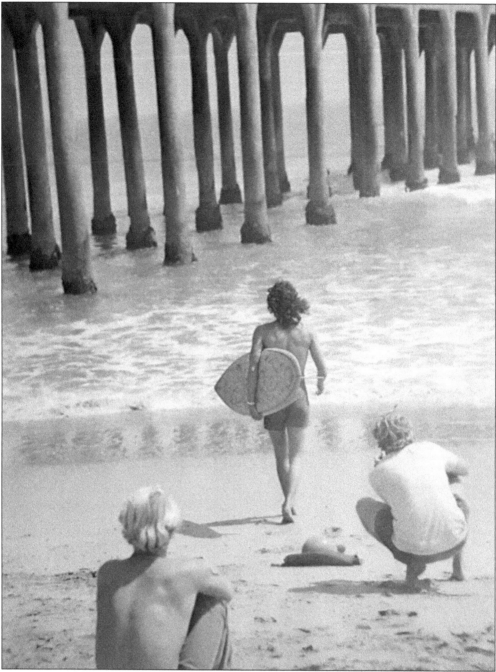

Corky Carroll's exit was not the only curtain call in 1972. Competitive surfing saw a mass exodus that year with the US Surfboard Championships holding its last event and pro surfing in HB entering its own version of the Dark Ages. On the upside, no more helmets. Here, around 1972, David Nuuhiwa heads out, leaving the confines of competition behind on the sand for a more free-spirited ride ahead. (Courtesy of the City of HB Archives.)

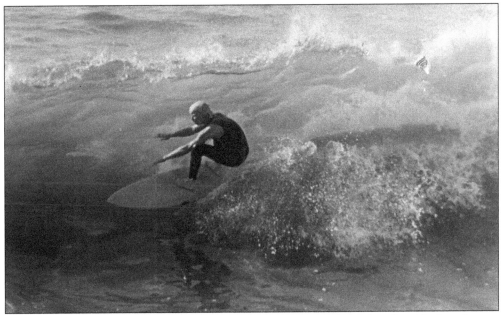

With the "plastic trip" of competitions gone, antiestablishment free-riders flourished, and a new wave of innovation followed. Helping lead the way was Chris Hawk. Hawk played an integral part in the shortboard revolution as both surfer and shaper, opening Hawk's Surfboards on Fifth Street. Fittingly, when later inducted into the Surfers' Hall of Fame, Hawk inscribed, "Peace—Love—Surf." (Courtesy of Bob Bolen.)

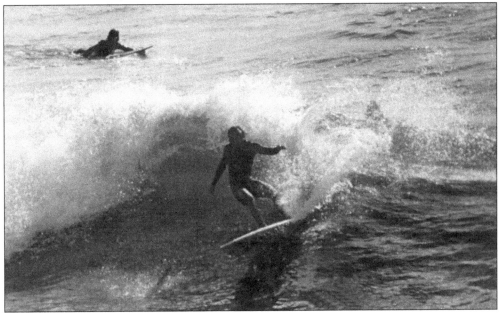

Rod Treece, the grandson of HB's first local surfer Bud Higgins, carves a South Side wave around 1970 on a Chris Hawk-shaped seven-foot-two-inch rounded pin tail. Treece started on surf mats rented from Dwight's and then moved up to his mom's Gordie designed twin-fin bellyboard. The shortboard he rides here is a far cry from the 135-pound plank his grandfather started on 40 years earlier. (Courtesy of Rod Treece.)

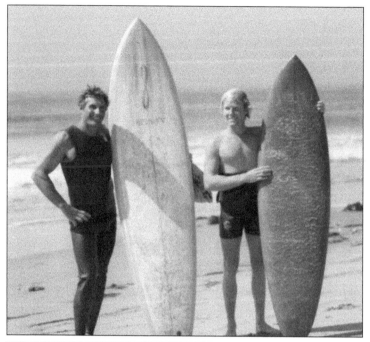

During the revolution, the surfing population decreased as beginners, and many longboarders had trouble adapting. George Strempel was not one of them. Despite starting on balsa longboards nearly 30 years prior, he was all for the new shorter designs. Here, he holds an Infinity surfboard at Bolsa Chica in 1972 with friend Ricky Rutherford. Evidently, Strempel also had no problem jumping from wool sweaters to wetsuits. (Courtesy of George Strempel.)

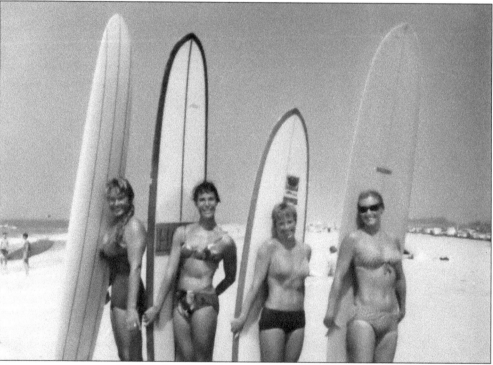

Not everyone gave up their longboards. Able to surf circles around the guys at any length, these four pioneers in women's surfing traded in overcrowded, shortboarding by the pier for more chill vibes up the coast at Bolsa Chica. From left to right, the legendary Marge Calhoun, the first women's world champion, is joined by Liz Erwin, Georgia Tanner, and Jennifer Strempel, wife of Keoki member George Strempel. (Courtesy of George Strempel.)

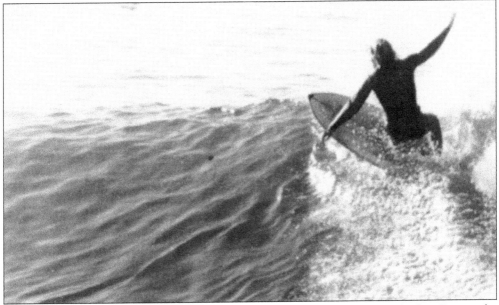

Rod Treece captured Claine Brown of North Carolina tearing it up on surf safari. During the 1970s, HB was a traveling surf hub. Thanks to shortboards making waves more rideable than ever, surfers from all over were drawn to the area. For bigger names, HB was a testing ground before taking innovations abroad. For others, it was just a fun place to rip no matter the occasion. (Courtesy of Rod Treece.)

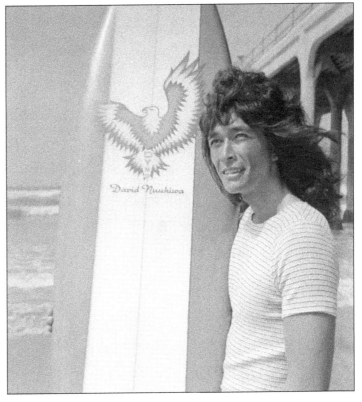

Surfers were not the only ones attracted to HB's surf scene. Take Dyno owner Dick Lippincott, a businessman with no ties to surfing who made a fortune selling batteries. Despite lacking industry experience, the talent he got through Dyno's doors was top-notch, like David Nuuhiwa, shown here during a 1972 photoshoot holding a custom, single-fin rounded pin tail emblazoned with his now iconic eagle logo. (Courtesy of the City of HB Archives.)

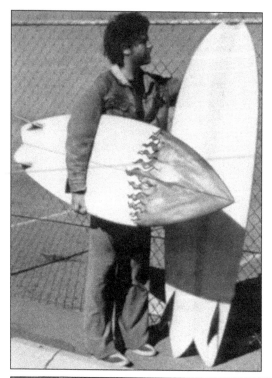

First-class shapers worked Dyno's factory, such as Terry Martin, Steve Walden, and Carl Hayward. For a while, Dyno also boasted HB's youngest head shaper in 19-year-old Steve Brom. Putting out 10 boards a day at $6.35 a piece, he made the board David Nuuhiwa holds on the previous page. Here, Brom holds a Gunfish (precursor to his popular Rocketfish design), along with an experimental dual-pointed shortboard. (Photograph by Brian Gillogly/LeftPeak Productions.)

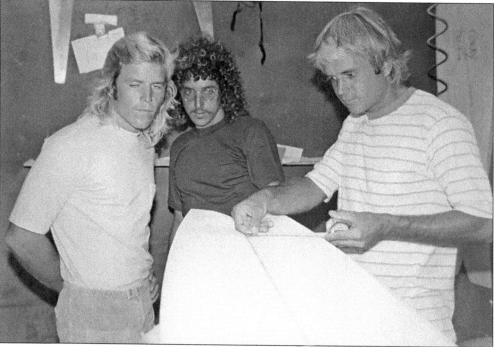

From left, Sam Hawk, Craig "Owl" Chapman, and Dick Brewer measure the swallow tail of a fish in progress at Dyno's factory on Fifth Street in 1972. Brewer, one of the best boardmakers in history, was at the forefront of the shortboard revolution with his mini-gun and a favorite amongst the world's best riders, including Sam and David Nuuhiwa. (Courtesy of the City of HB Archives.)

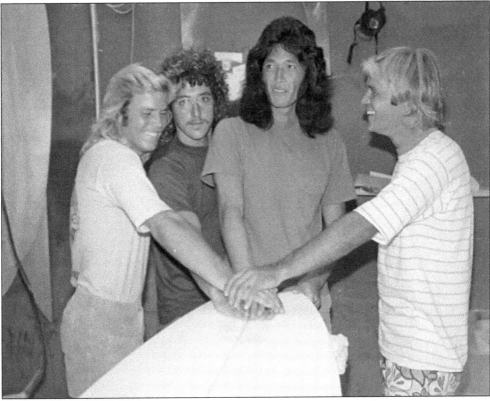

Sam Hawk (left) grew up riding HB alongside brothers Chris and Tom and was called "the perfect 70s surfer" by historian Matt Warshaw. Owl Chapman grew up surfing Southern California before becoming an avant-garde tuberider of Hawaii's North Shore, shaping with Dick Brewer. Here, Sam, Owl, and Dick are joined by David Nuuhiwa—four of the greatest shortboard pioneers together in one great shot. (Courtesy of the City of HB Archives.)

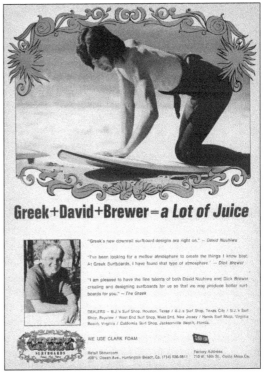

This 1970s Greek Surfboards advertisement is a perfect example of why HB is called a surf community. Though competition existed, collaboration ruled as surf shops like Bob Bolen's worked with top shapers like Dick Brewer and hot riders like David Nuuhiwa. (Courtesy of Bob Bolen.)

79

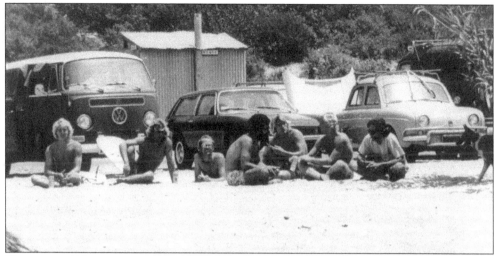

The same collaborative spirit went for the teams of the era. Just like with his designs, Bob "the Greek" Bolen embraced the times with his carefree surf crew, claiming some of the best shortboard riders around. Around 1973 from left to right sit Jeff Smith, Lonnie Buhn, John Davis, the Greek, Klayne Brown, John Van Ornum, and Jack Cerrito. Grettle the dog stands right. (Courtesy of Bob Bolen.)

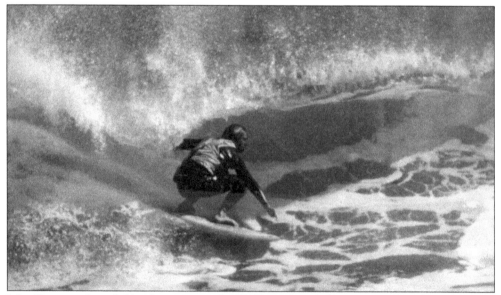

John Davis gets barreled by the pier around 1970. Davis attended Huntington Beach High School and, in 1967, captained the school's first surf team. (It was technically called a "surf club," since surfing was considered too disreputable to have its own official school team.) After graduating, Davis consistently placed amongst the world's top competitive surfers and became a team rider for the Greek. (Courtesy of Rod Treece.)

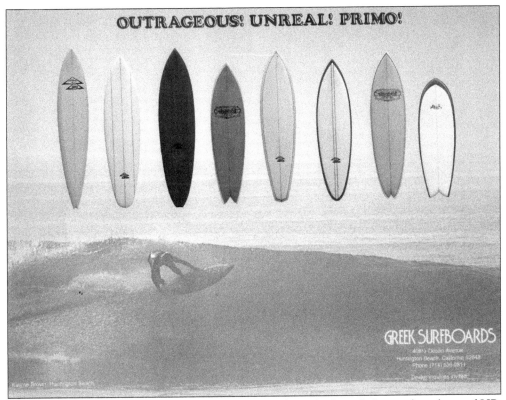

Bob Bolen, along with the rest of the growing number of talented shapers based out of HB, continued to advance shortboard design to its limits. This advertisement shows the Greek's impressive quiver of shortboard offerings and can be viewed as a snapshot of many of the various designs that came out of the era. The surfer is team rider Klayne Brown. (Courtesy of Bob Bolen.)

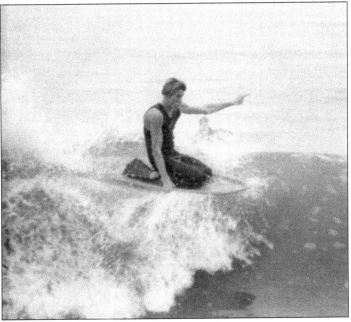

A surfer skims along on a Greek-designed kneeboard. Remaining true to the revolution's roots and inspired by the designs of George Greenough, the Greek created this "flex-spoon" with meticulously shaped rim and transparent fiberglass deck. When all was said and done, the shortboard revolution was essentially stand-up surfing's attempt to emulate what the likes of Greenough, Steve Lis, and this kneeboarder had been doing all along. (Courtesy of Bob Bolen.)

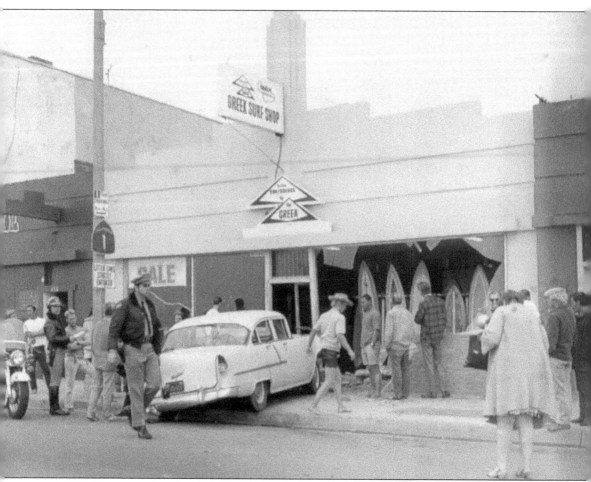

A 1955 Chevy smashes through the front of the Greek's surf shop around 1969. Thanks largely to the Huntington Beach surf scene's embrace of the shortboard revolution, a deluge of surf shops flooded the area. Soon, one literally could not drive down the street without hitting one. (Courtesy HBHRB for City of HB.)

Six

Surf Ghetto

1970–1980

Huntington Beach surf culture came into its own during the 1970s. Boosted by the shortboard revolution, the surfing lifestyle took on a newly colorful, more rebellious look; a stark contrast to the pristine image Hollywood had sold on big screens the decade prior. HB helped lead the way.

It was around this time downtown Huntington Beach became affectionately known by some (and less affectionately by others) as the "Surf Ghetto." Part myth, part truth, and entirely a trip, the scene was one of the area's most prosperous, at least where surfing was concerned. With more surf shops than one could count and an influx of talent, HB became a mecca of wave riding innovation and culture.

Though undeniably derelict with few venturing downtown at night, unfettered surfers felt right at home in this "seedy" surf spot, with plenty to kindle their stoke, like eating sprout sandwiches from Jan's, catching the latest tuberides at the Surf, rocking out to Honk at the Bear, enjoying cheap food and lousy drinks at Hungry Joe's, and talking story at George's. Wayward groms would squat in abandoned oilman housing shacks and routinely return from sessions with tar on their feet. Surf shops were less concerned about making money than having a good time, and many of the best surfers would go relatively unknown. Like Greg Clemons, ripping 360s through the pier on a self-shaped board then driving away in his truck blasting stereo speakers and wearing a cowboy hat. In more ways than one, it was like the wild west of surfing, with its very own Main Street Saloon to boot, a one-time brothel turned rowdy bar and billiard hall where nocturnal bohemian surfers could let loose.

Haight-Ashbury meets Hawaii—that was Huntington Beach's Surf Ghetto.

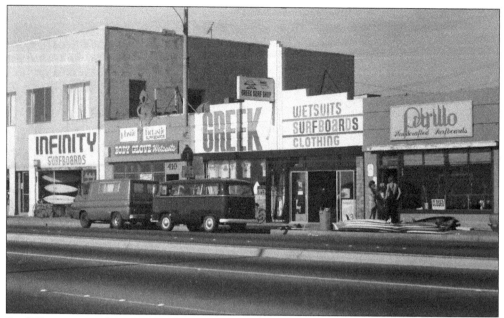

Surf Ghetto is seen here at its peak in 1974. Just as impressive as the lineups in the water were the lineup of surf shops populating the area surrounding Main Street and the PCH. Infinity, Plastic Fantastic, Greek Surfboards, and Petrillo show why when it came to surf culture, Huntington Beach was the place to be. This photograph was taken on November 12, 1974. (Courtesy of Douglas Miller.)

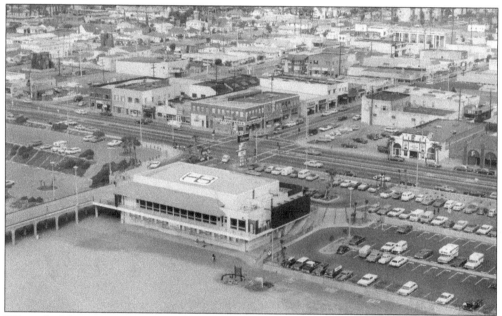

When the Huntington Center (now Bella Terra) opened at HB's northern tip in 1966, it created an economic downtown downturn allowing the surf crowd to coast in. This 1970 aerial of Surf Ghetto features the Golden Bear (right), Jack's Surfboards (center), the surf shops in the photo above to its left, and Surf Theatre directly behind one street over. The "HB" adorned building is the Fisherman restaurant (presently Duke's). (Courtesy of the City of HB Archives.)

A distinctive sight cruising HB's Surf Ghetto were the colorful signs adorning its surf shops, with many designed by Rod Treece, whose father, Don, created the logo for Gordie Surfboards. The following photographs showcase Rod's work, such as this for the original Huntington Beach Surf & Sport on Fifteenth Street. (Courtesy of Rod Treece.)

The unmistakable front of Jack's Surfboards. Over the years, the sign at Jack's was repainted so often it became a bit of an inside joke for the area. Here is a version designed by Rod Treece. Notice the windows at the building's top. These were apartments where surfers often lived, providing a perfect view of the day's conditions. (Courtesy of Rod Treece.)

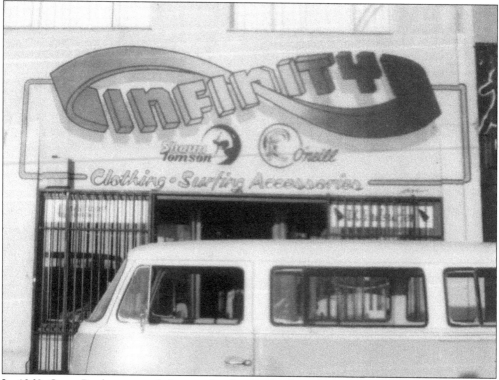

In 1968, Steve Boehne started shaping for Gordie Surfboards. When shortboards took off, he shaped for several HB shops under his own label, "Surfboards by Steve," until opening Infinity Surfboards in 1971 at Fifth and PCH with wife, and champion tandem surf partner, Barrie. This sign was one of the most colorful and creative in the area. (Courtesy of Rod Treece.)

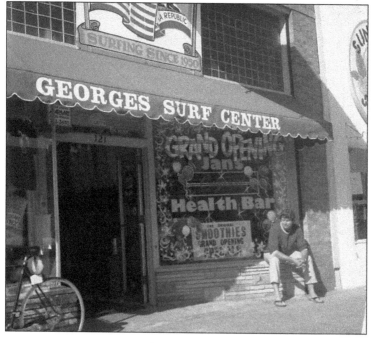

At Surf Ghetto's peak, there were over 20 surf shops in town. Its cultural meeting point was George's Surf Center, presided over by George Draper, sitting in front. A major reason George's was so popular was Jan's Health Bar. Originally opened behind the shop by *Surfer's Journal* cofounder Steve Pezman in 1969, Jan Gaffney took over in 1972 and turned it into HB's "it" spot. (Courtesy of Russ Rinner, Awnings by Russ.)

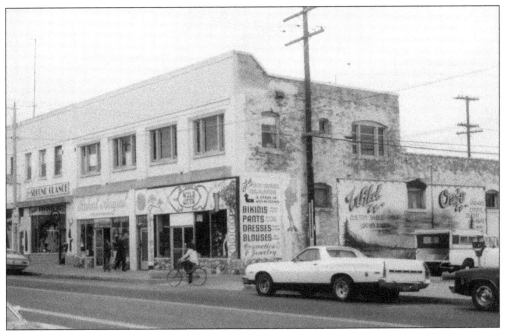

After appearing in *The Endless Summer*, Robert August became a salesman for Jacobs Surfboards and freelance shaper for Petrillo, Plastic Fantastic, and Chuck Dent. In 1976, he opened his own shop on Main Street, seen here between two clothing stores. It lasted until a fire destroyed the building in 1985. This image was taken on March 10, 1976. (Courtesy of Douglas Miller.)

At the corner of Sixth Street and PCH stands Windansea on March 10, 1976. Owned by Guy Guzzardo, the shop housed talented shapers including Ed Angulo and Bob Hurley, who began his career here during the 1970s. He later opened Hurley Surfboards, brought Billabong to the United States, and started Hurley International, all of which helped land him a spot on *Surfer* magazine's "25 Most Powerful People in Surfing." (Courtesy of Douglas Miller.)

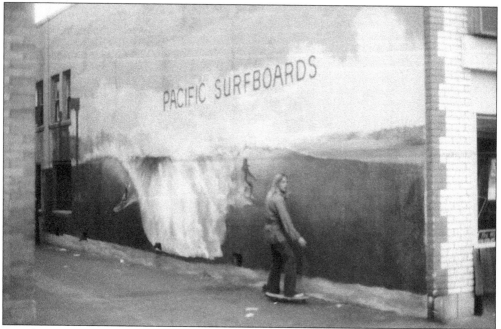

A "sidewalk surfer" coasts out of the alley beside Pacific Surfboards at 111 Main Street on March 10, 1976. Later, Pacific became Sunline Surfboards, with the historic Merrilee's Swimwear Boutique on the mezzanine level (located today around the corner on Fifth Street). The mural was painted by surfer-artist Walter Viszolay. (Courtesy of Douglas Miller.)

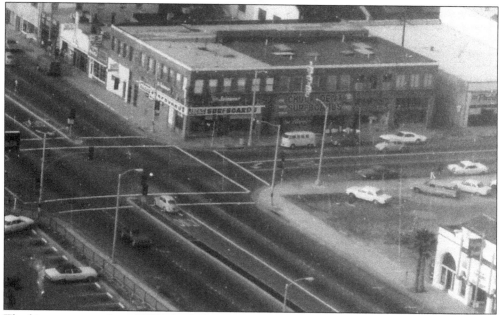

The biggest personality of HB's Surf Ghetto was Chuck Dent. Though not an elite surfer, this acid-tongued, self-described "flatland ho-daddy transplant" and "original angry young man of surfing" was an imposing fixture of the community. In 1964, he opened a shop on Main Street beside Jack's lasting until the mid-1970s, during which he helped modernize the industry by creating a surf retail mecca. (Courtesy of the City of HB Archives.)

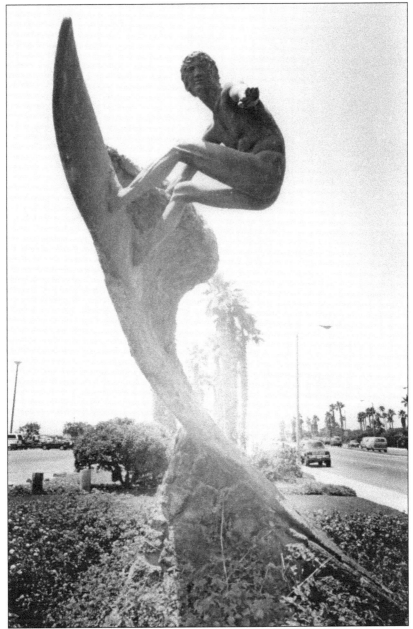

The Ultimate Challenge, sculpted by Edmond Shumpert in 1976, was originally commissioned for the city hall courtyard, but town officials, offended by its nakedness, moved it to shore with the rest of Surf Ghetto's beach bums. The statue was actually based off a much smaller near identical statue created by Shumpert called *The Rollercoaster*, which, for several years, was awarded as a trophy to outstanding surfers at the US Surfboard Championships. Eventually, the city asked him to create a life-size version. He sculpted and cast the piece in Italy, which all told weighed 3,000 pounds, and afterward had it shipped to HB. Of his famous statue, Shumpert said that his intent was to create a Michelangelo-esque bronze. In 2006, HB banned public nudity, leaving *Nude Dude* as the last remaining rebel, riding an epic wave beside cars cruising the PCH. (Courtesy of the City of HB Archives.)

In 1969, a memorial was erected at the base of the pier to honor Duke Kahanamoku. The bronze bust was mounted on lava-rock with the inscription, "He will always be remembered for his long aloha." Here in 1972, a woman adorns Duke with a lei at his original location. The bust has since been moved inside HB's International Surfing Museum. (Courtesy of the City of HB Archives.)

In 1974, Rick, Carole, and Chuck Babiraki took over the much-beloved Golden Bear and continued its tradition of booking the biggest acts of the time. On March 10, 1976, Corky Carroll, now a professional musician, played the bear with his Funk Dog Surf Band. Legendary Laguna Beach street photographer Douglas Miller, who shot many of the photographs in this chapter, played flute in the band. (Courtesy of Douglas Miller.)

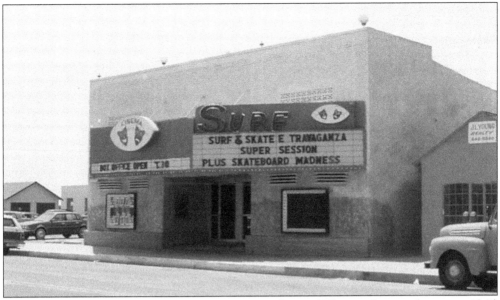

Opened in 1925 as Scott's and renamed the Roxy, the Surf Theatre (renamed again in 1941) would come to house one of wave riding's most endearing art forms: the surf film. With a 350-seat capacity, double features, tickets for a quarter, Pal Club grab bags, and easy backdoor entry for "groms" (see page 18), the Surf was a true HB landmark. (Author's collection.)

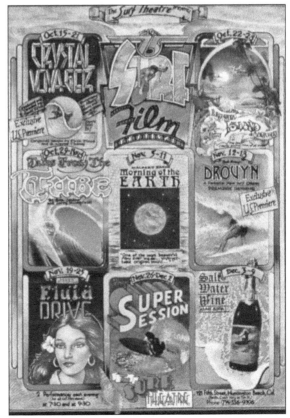

Though it screened popular films of the day like *Billy Jack* and *The Song Remains the Same*, it was Surf Theatre's role as a bonafide surf and skate venue that set it apart. During annual festivals like this in 1975, it was not unusual to find local preachers passing out pamphlets outside forewarning, "Don't let surfing be your God!" (Courtesy of David Lessard.)

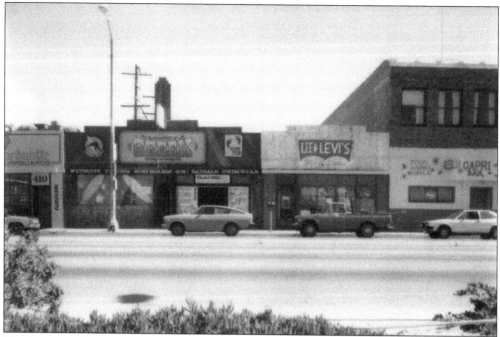

Nearly 10 years later, downtown HB has a distinctively different look compared to this chapter's first photograph. Not long after this was taken in 1980, Greek Surfboards closed, marking the end of an era. While other surf shops would remain a little longer, the area surrounding Main and PCH was about to undergo a massive redevelopment, leaving its Surf Ghetto a fond memory. (Courtesy of the City of HB Archives.)

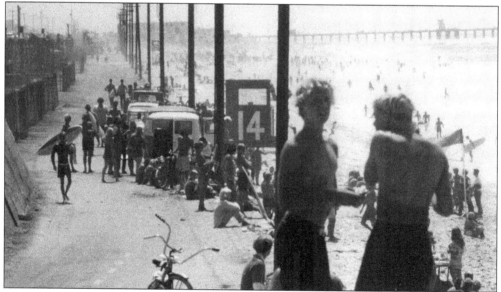

Of course, HB's Surf Ghetto was not defined by its buildings, rather the people who called it home. With an oil rush, surf boom, and design revolution behind them, HB's surf scene was about to enter its most disruptive era yet. But before this tide of change, a rambunctious group of hotshot surfers and shapers sought to close the decade on a winning high note. (Courtesy of the City of HB Archives.)

Seven

THE HOLE IN THE WALL GANG SURF TEAM
1970–1980

Surf clubs and teams have had a long and storied history in Huntington Beach. Many of the shops in town at one point or another had a team of riders, like the Greek's or Gordie's exhibition team. The Keoki's board room can be considered HB's first surf club, followed by a batch of more organized groups from the 1960s including the Cliff's South Sea Surf Club and the Warner Street Surf Club. In 1963, the city-sponsored Huntington Beach Surf Club was formed by the HB lifeguards and led by chief Vince Moorehouse, with the goal to "build athletes instead of bums." The Huntington Beach Surfing Association (HBSA), one of HB's longest, largest, and most enduring clubs, formed during the early 1960s and was notably mentored by Duke Kahanamoku. Later came the West Side Board Riders and Lake Street Board Riders. Today, the Huntington Beach Longboard Crew, Wahine Kai Women's Surf Club, and West Coast Board Riders continue the tradition.

Then there is the Hole in the Wall Gang Surf Team.

The Hole in the Wall Gang Surf Team was less a team or club than a community. In a way, it was Huntington Beach. A little rough around the edges, fun-loving, filled to the brim with talent, and a hub for the best surfing had to offer. This coalition of surfers, shapers, and industry leaders helped define the competitive scene in HB at a time when both clubs and contests were falling out of favor.

In 1967, the United States Surfing Association, formed to help improve the deteriorating public perception of surfing, split into regional groups. Soon after, California's Western Surfing Association (WSA) reintroduced team competition, a call back to when contests were less-commercialized, more club-oriented affairs. Around 75 teams participated, including a group of four hotshot Huntington Beach surfers.

After finding early success, John Van Oeffelen, Bob Milfeld, Randy Lewis, and John Boozer were looking to grow their team. Since a few were already riding Gordie Duane–designed boards, they approached the famed shaper about joining and he became the first new recruit of what came to be known as the Hole in the Wall Gang Surf Team.

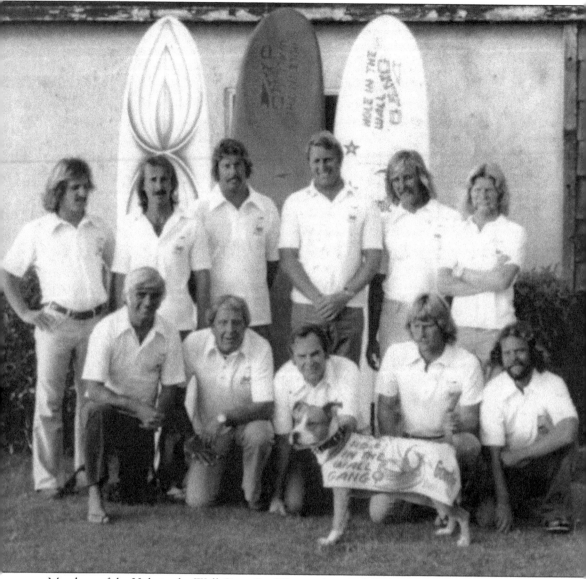

Members of the Hole in the Wall Gang Surf Team take a mid-1970s group photograph outside Gordie Surfboards. Pictured from left to right are (first row) Bill Rainforth, Bob Carbonell, Gordie Duane, Chopper, Bob Milfeld, and John Boozer; (second row) Lonnie Buhn, Chris Cattel, John Taylor, John Van Oeffelen, Randy Lewis, and Steve Holt. After Duane joined the team, his Thirteenth Street surf shop became their home base, and they started to recruit more local talent. Very quickly, the team's numbers grew and they set about dominating the amateur competitive circuit. (Courtesy of Chris Cattel.)

Bob "Sniffer" Milfeld, an amazing surfer and talented airbrusher and artist, designed the Hole in the Wall Gang Surf Team logo as well as this graphic of a surfer shooting the pier within a Gordie-esque shield. Like all amateur squads, the team paid for their own shirts and jackets as well as entry fees, lodgings, and travel expenses with little sponsorship. (Author's collection.)

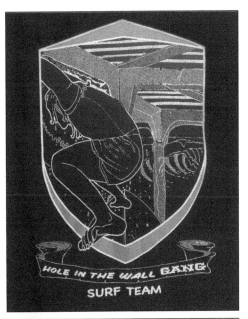

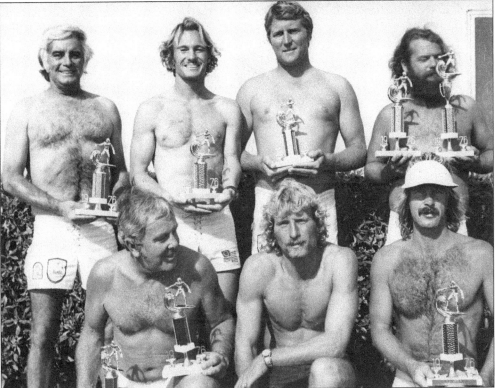

Throughout the 1970s, the Hole in the Wall Gang Surf Team was amateur surfing at its best. At one point, they went unbeaten for four years. Here, they hold trophies from a clean sweep at a 1976 WSA contest in HB. Pictured from left to right are (first row) Bob Carbonell, Bob Milfeld, and Chris Cattel; (second row) Bill Rainforth, Guy Grundy, John Van Oeffelen, and John Boozer. (Courtesy of Chris Cattel.)

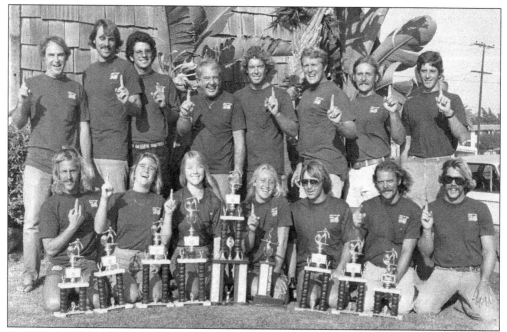

In 1977, the Hole in the Wall Gang Surf Team beat the Hawaiians as the nation's top team at the US Surfing Championships in San Onofre. Commemorating the victory from left to right are Lonnie Buhn, Morghan Floth (later Boozer), Bobbie Smith, Cindy White, Chris Cattel, John Boozer, and Robert Kooken; (second row) Gordie Duane, Jim Fuller, Duncan McClane, Bob Carbonell, John Taylor, John Van Oeffelen, Randy Lewis, and John Sweeny. (Courtesy of Chris Cattel.)

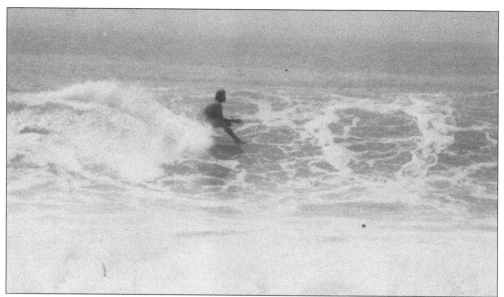

Randy Lewis pulls off a textbook cheater five (crouching at the board's front and extending the leading foot off the tip) in this c. 1975 photograph. Lewis is one of HB's greatest surfer-shaper combos. He rode for both Vardeman and Chuck Dent, helped form the Hole in the Wall Gang, and later branched out with his own signature line of boards. (Author's collection.)

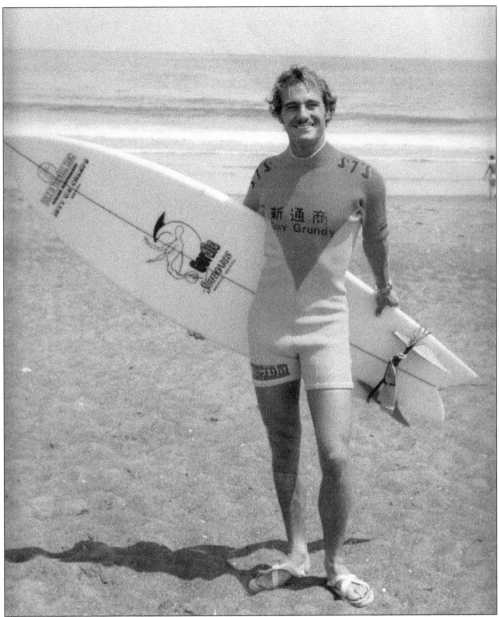

In 1978, Guy Grundy represents Huntington Beach and the Hole in the Wall Gang Surf Team abroad during a visit to Japan (joined by Randy Lewis) to work with local board manufacturers. The board is a Gordie. Grundy was a top HB surfer during the 1970s, though is perhaps best known as a skateboarder, setting the downhill speed Guinness World Record in 1975. (Author's collection.)

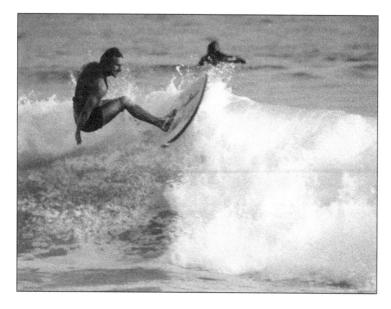

Like Randy, Guy, and the rest of the team, Lonnie Buhn (shredding it here in the 1970s) had an impressive career both as part of the Hole in the Wall Gang and beyond. Buhn was a West Coast High School Champion and later WSA's top-rated surfer in California. He also worked as a world-renowned laminator and shaper. (Author's collection.)

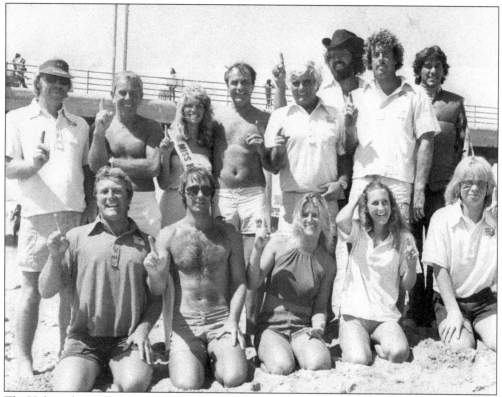

The Hole in the Wall Gang Surf Team brought together local surfers, shapers, and WSA directors, with a roster between 20 to 30 members, including these from around 1978. Pictured are (first row) John Van Oeffelen, Chris Cattel, Morghan Boozer, Robyn Taylor, and George Lambert III; (second row) George Lambert Jr., Bob Carbonell, Miss HB (not an official member), Gordie Duane, Bill Rainforth, Mike Morelli, John Taylor, and Greg Shuman. (Courtesy of Chris Cattel.)

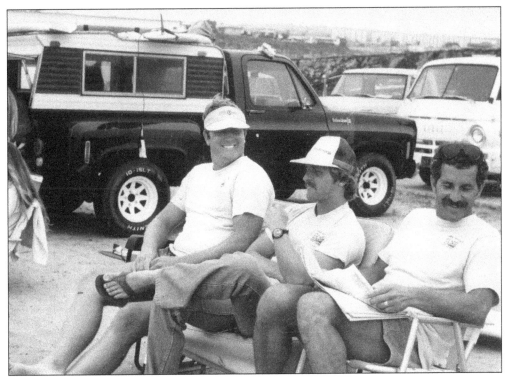

In 1979, Chuck Linnen joined to help the Hole in the Wall Gang Surf Team win the WSA West Coast team championships in South Carlsbad. Here, during that contest, Linnen (far right) is joined by John Van Oeffelen and Lonnie Buhn (center), all wearing their Hole in the Wall Gang Surf Team shirts. (Authors' collection.)

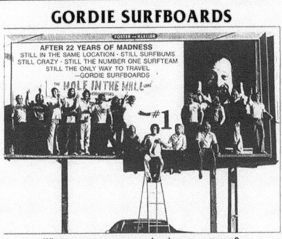

This advertisement features the Hole in the Wall Gang Surf Team's formidable lineup. As seen in many of this chapter's photos, they adopted the "We're Number One" hand gesture as their signature. When Toyota dealer Bill Maxey appeared on a billboard doing the same, the team commandeered it as their own. At center sits one of their most vocal members, Chuck Dent, who wrote the advertisement. (Author's collection.)

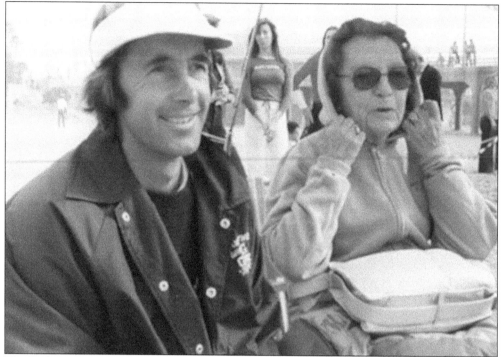

The Hole in the Wall Gang Surf Team was supported by several locals around town like *Hunting Beach News* editor George Farquhar, International Surfing Museum founder Natalie Kotsch, and "the First Lady of Surfing" Nancy Katin. Katin sits here with Chris Cattel at a Katin Pro-Am contest. During the 1950s, she and her husband, Walter, created the first pair of surf trunks (a precursor to boardshorts). They later provided custom Kanvas by Katins to the team. (Courtesy of Chris Cattel.)

The Katin Pro-Am Team Challenge bridged the gap between the pro and amateur ranks and included nearly every top surfer of the time competing against each other. In 1979, amidst all that talent, the Hole in the Wall Gang's Richard Andino placed third overall. His medal (shown here) added to their already impressive accolades as district, West Coast, and national champs. (Author's collection.)

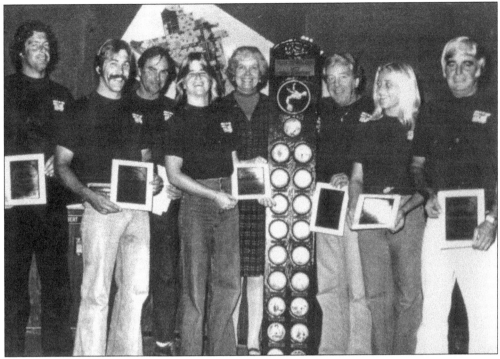

On December 12, 1977, the City of Huntington Beach presented the Hole in the Wall Gang Surf Team with an official certificate of recognition. John Taylor, John Kooken, Gordie, Morghan Boozer, Cindy White, Bob Carbonell, and Bill Rainforth join Norma Gibbs (center) during the ceremony. Norma Gibbs was HB's first female council member and mayor, (Courtesy of *Huntington Beach News.*)

The town's recognition of the Hole in the Wall Gang was momentous. For the first time ever, the city officially acknowledged a group of surfers for their role in providing an "outstanding service" to the town. Considering both sides had been at odds ever since the Keoki had their board room commandeered in the late 1940s, this was definitely a shift in the sand. (Author's collection.)

THE CITY OF HUNTINGTON BEACH,
CALIFORNIA

Presents This Certificate To
" HOLE·IN·THE·WALL GANG "
SURF TEAM

in recognition of outstanding service to the city of
Huntington Beach

Given This _12TH_ Day of _December_, 19 _77_

MAYOR

1776-1976

101

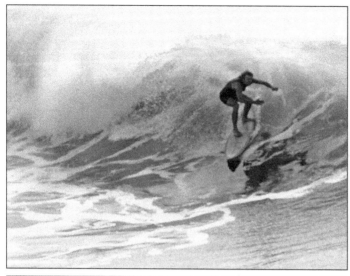

Chris Cattel surfs South Side on a Vardeman board in 1976. Over his career, Cattel racked up an impressive tally of first-place finishes, such as winning HB's inaugural Summer Surfing Championships in 1971, and receiving the "Outstanding Huntington Beach Surfer Award." All told, he certainly helped the Hole in the Wall Gang Surf Team earn the right to call themselves "number one." (Courtesy of Chris Cattel.)

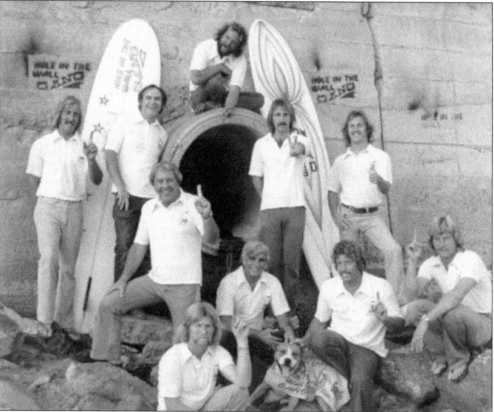

Several members of the Hole in the Wall Gang Surf Team take a photograph by the spot that gave them their name. From left to right are (sitting) Steve Holt, Bill Rainforth, John Taylor, and Bob Milfeld; (standing) Randy Lewis, Gordie Duane, Bob Carbonell, Chris Cattel, and Lonnie Buhn. John Boozer sits on the pipe. Milfeld's pet pitbull and team mascot Chopper lays center. The team's name comes from the drainage hole seen here in a beach retaining wall across from where Gordie's surf shop was located at Thirteenth Street. (Courtesy of Chris Cattel.)

Eight

TIDES OF CHANGE
1977–1990

Despite Surf Ghetto's innovations and the Hole in the Wall Gang's triumphs, surfing in California as a whole fell into a bit of despair during the 1970s.

John Severson probably exemplified it best in his classic surf film *Pacific Vibrations*, where baton-twirling policemen prowl HB for "unruly" surfers while a disaffected youth looks on from the pier, predicting the end of surfing as it is known it in Huntington Beach within three to four years. Thanks to several key initiatives by decade's end, this apocalyptic angst, on both sides, began to fade.

A major factor was HB's burgeoning high school surfing programs. By the mid-1970s surfing had become a full-fledged team sport, offering varsity letters to surfing athletes. Bolstered by this growth, a group of local teachers and coaches founded the National Scholastic Surfing Association (NSSA), a competitive student-centric organization whose participants were selected not just for their surfing ability, but also academic achievements and service to the community.

In 1977, Kanvas by Katin reintegrated California into the competitive surf scene when it started the Katin Pro-Am Team Challenge in HB. Early on, the team to beat was the Bronzed Aussies, an elite squad of Australian surfers pushing the sport past its antiestablishment soulfulness and into the ranks of professional mainstream marketability. Two of its members—Ian "Kanga" Cairns and Peter "PT" Townend—were recruited to coach the NSSA National Team. Upon arrival in HB, they founded Sports & Media Services and created the Op Pro in 1982, the biggest surfing contest to date. Shortly after, Cairns became director of the Association of Surfing Professionals (ASP) and moved professional surfing's world headquarters to HB.

With the 1980s well underway, Huntington Beach was back at the center of the surfing world, though it would not come without growing pains. Amidst this resurgence, the city sought to improve its own status with a massive retail and commercial expansion. The result would completely change the face of downtown. And after two devastating storms that destroyed its most famous landmark and one harrowing surfing-related riot, Huntington Beach found itself once again in search of a new identity.

Yet these disasters and developments that rocked HB during this era, both natural and manmade, cleared the way for a tide of change that opened up the city and its surf scene to an enduring future.

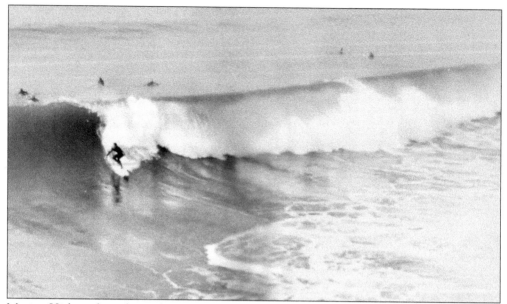

Marina High surfers take to the water. By the late 1970s, high school surfing had gained more credibility and formally organized into the Sunset Surfing League. Orange County schools also began offering surfing as a physical education elective. With surfing's newfound acceptance and the work of the NSSA, the image of laid-back, rebellious surfers had been replaced with well-trained student athletes or, at the very least, got students stoked to go to class. (Courtesy of *Huntington Beach News*.)

Bud Llamas, the standout star of the era, holds a Hawk Surfboard during an NSSA contest around 1978. Llamas was part of Huntington Beach High School's surf team and a powerful goofyfooter, whose gouging turns and innovative aerials set an early tone for modern surfing. In 1979, he won 8 of 10 NSSA contests, then turned pro in 1980 to compete on the ASP tour over the next seven years. (Author's collection.)

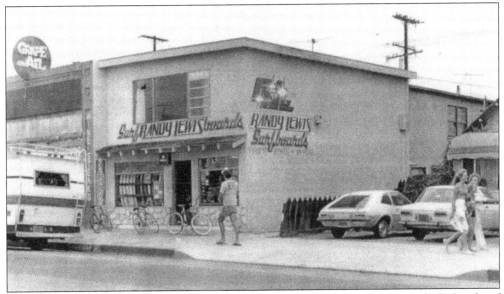

In 1977, Randy Lewis opened his surf shop at 208 Fifth Street to stay involved with the local surf scene. It remained there until 1987. Recalling the Surf Ghetto's heyday, Lewis's shop provided an experience that was quickly vanishing downtown, housing a surf family of team riders and providing custom shaped boards made by a true craftsman. (Courtesy of Randy Lewis.)

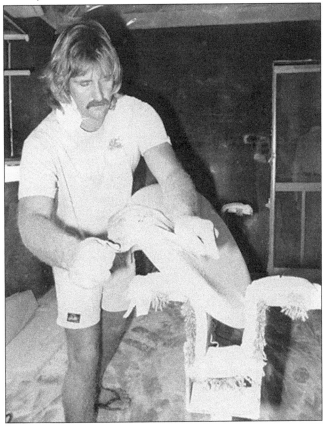

Randy Lewis works in the shaping room during the late 1970s. Randy made his first board in his backyard and later started his career planing down blanks for Vardeman Surfboards. Under the tutelage of Gordie Duane, he refined his skills, going on to craft some of the best boards in the business. Among the greats who rode them were John Boozer, Michael Ho, Joey Hawkins, and Bud Llamas. (Courtesy of Randy Lewis.)

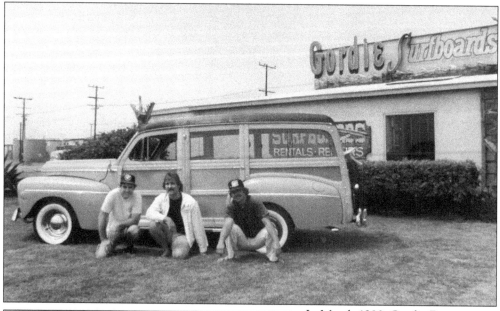

In March 1980, Gordie Duane lost the lease to his surf shop on Thirteenth Street. The property had been sold to developers in an early sign of citywide changes to come. Shortly before its closure, Gordie (left) took this shot with Randy Lewis, Lonnie Buhn, and a Woodie station wagon. Ever the craftsman, Gordie continued to shape boards out of his home. (Author's collection.)

After a decade of lying dormant, the US Surfboard Championship was reborn in 1982 as the Op Pro. Sponsored by surf apparel company Ocean Pacific, this stop on the ASP played host to some of the best (and worst) moments of surfing over the next 10-plus years. (Courtesy of the Orange County Archives.)

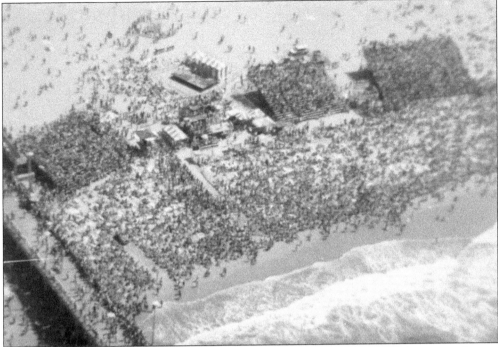

Dubbed the "Super Bowl of Surfing," the Op Pro was by far the world's biggest and most commercialized surf contest to date, attracting crowds as large as 100,000, such as this one seen from above in 1983. (Courtesy of the Orange County Archives.)

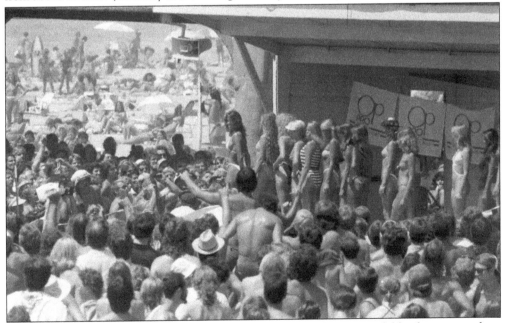

The Op Pro proved surf competitions did not need surfing to draw a crowd, like the one seen here in 1983 at one of its more infamous sideshows: the bikini contest. An even larger, unrulier crowd descended on HB a few years later in 1986, making national news when hundreds of spectators rioted and burned cars during the event's finals. (Courtesy of the Orange County Archives.)

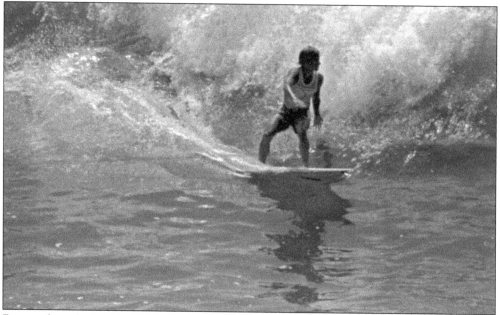

Despite the setback of the 1986 riot, the Op Pro proved a boon to the future of competitive surfing. It was the first time instant scoring and the priority rule were used, providing exciting real-time results and a right of way to waves. This was a huge success right off the bat, highlighted in epic showdowns between Southern California native Tom Curren and Australia's Mark Occhilupo. (Courtesy of the Orange County Archives.)

In March 1983, one of the worst storms in decades struck the West Coast, bringing devastating tides to shore. Of course, thrill-seeking surfers loved it, several of whom braved the conditions and found themselves surfing eye level with the pier. (Courtesy of the City of HB Archives.)

The pier survived—for five more years. In January 1988, another violent storm struck, this time removing a 250-foot chunk and pulling the End Café at its tip into the ocean. Shortly after that, the world-famous pleasure pier George Freeth christened 75 years earlier was cordoned off and scheduled for demolition. (Photograph by David E. Wentworth Jr., courtesy City of HB Archives.)

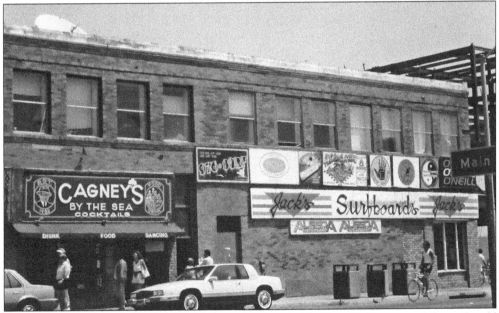

In 1985, the Huntington Beach headquartered Surfline, led by Sean Collins, turned the surf world on its head when it unveiled a way to accurately predict swells as far as a week in advance. For 55¢, surfers could dial 976-SURF (seen promoted here outside Jack's) and get the conditions on 22 different breaks along the coast. Another 55¢ would buy them a 72-hour forecast. (Courtesy of the City of HB Archives.)

In 1987 Natalie Kotsch established the Huntington Beach International Surfing Museum. Though she only stuck her toes in the Pacific one time and never surfed, Kotsch fell in love with surf culture, founding a museum befitting HB's illustrious surfing history. Here, she holds a Hole in the Wall Gang Surf Team trophy beside Bobbie Smith, a member of both the Gang and Gordie Duane's exhibition team. (Author's collection.)

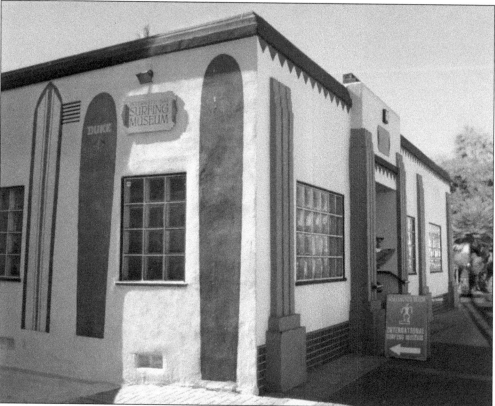

Originally located on Walnut Street, Natalie Kotsch's museum moved in 1990 to this Art Deco site, a former dentist's office, at 411 Olive Avenue. The sidewalk placard features the museum's logo, an homage to surfing's first historical recording—a cave drawing of a surfer. A mural on the side showcases the evolution of surfboards with a large ancient Hawaiian board, classic early Duke Kahanamoku board, and 1930s Waikiki-style balsa redwood. (Author's collection.)

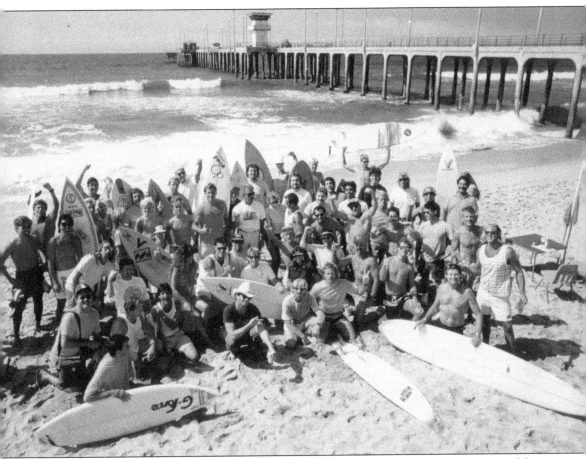

Some of HB's best gather for a group shot South Side in 1988. Consider this the '80s version of the photo from page 31. Most likely this was taken during the city-sponsored summer championships. Notice how empty the pier is, having been blocked off following the storm, with the End Café long gone. Of course, none of that was going to keep this group from enjoying the surf. Standing in the middle, cool as ever, is Chuck Linnen in sunglasses. In front, beer in hand, kneels Greg Clemons (in cowboy hat). He is pointing to, from left to right, brothers Chris and Sam Hawk. To the far right holding the longboard is George Draper. Others include Mike Downey, Jeffery Hess, Mike Kakuuchi, Steven Real, Bo Loveless, Robert Shaw, Pat Downey, Dave Kerr, Joe Vogan, Robert Rodriquez, Eddie Flores, Eddie Enriquez, Craig Posey, Robert Tjernagel, Brett Campbell, Todd Johnson, Bobby Burchell, Mike Crogstead, and Perry Putnam. (Courtesy of the City of HB Archives.)

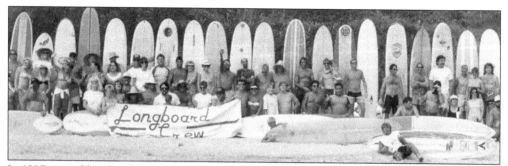

In 1985, several local surfers decided to coalesce and charge dues to pay for beer. The result became one of HB's most enduring (and charitable) surf clubs—the Huntington Beach Longboard Crew (HBLC), seen here at a 1987 contest. Members range from under 10 to over 75 years old. Some do not even surf, but just love the culture. In the early 2000s, under chairman Gary Sahagen, HBLC became a nonprofit, merging its fun-loving mission with a dedication to giving back to the community. (Courtesy of HBLC.)

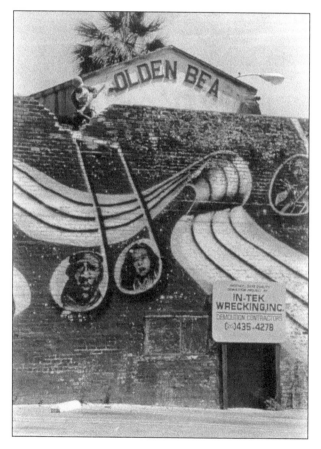

One of the worst casualties of the city's massive redevelopment was the Golden Bear. Deemed unsafe by new earthquake standards, it was razed to make way for the Pierside Pavilion that stands today. Jimi Hendrix and Janis Joplin seemingly mourn the occasion as one of the "butchers of the Bear" hacks away at artist Robert Wyland's iconic mural on May 18, 1986. (Courtesy of the City of HB Archives.)

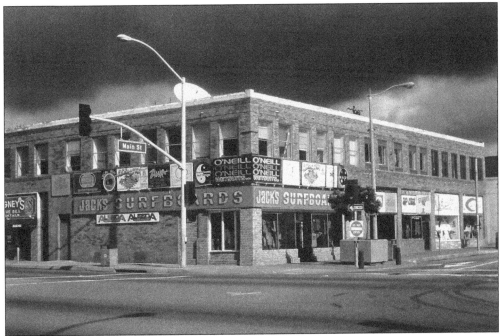

The ominous clouds seem to foreshadow the impending demise of Jack's Surfboards, seen here in 1987. Considered unsafe after its brick walls started bulging, the 70-year-old building would be razed in four years time. Though Jack's would return on a grander scale, the adjacent bar—Cagney's By the Sea—would not survive the transition, nor would Carl Hayward's surf shop, opened in 1979 at the far right corner. (Courtesy of the City of HB Archives.)

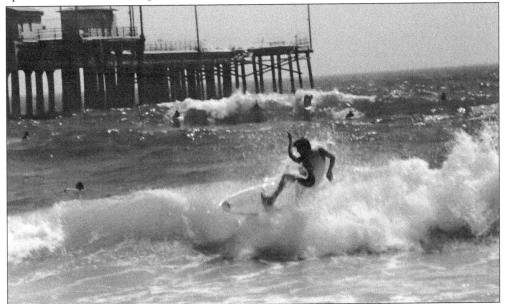

A surfer makes the most of a small inside wave on August 1989 as several others paddle to catch one behind him. Beyond them, the pier remains closed off, with the End Café noticeably absent. Despite all the changes and disruptions on land, it was business as usual in the water. (Courtesy of Kreg Jones.)

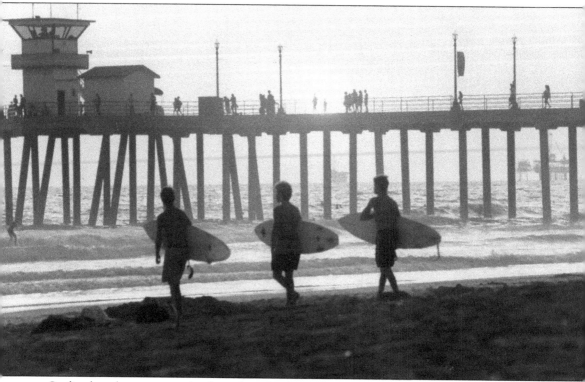

Surfing has always managed to keep the inland tumult at a distance. This photo, shot sometime between the storms of 1983 and 1988, shows people promenading the pier while a trio of young surfers heads out for a sunset session, blissfully indifferent to the changes behind them. (Courtesy of the City of HB Archives.)

Nine

SURF CITY, USA

1991–TODAY

"You know they're either out surfin' or they got a party growin' / Surf City, here we come!"

In 1991, Dean Torrence helped convince city leaders the town should adopt the name "Surf City, USA." While it would take another 17 years for it to become official, the song he made famous as part of Jan and Dean during the surf boom always felt right for HB.

In 2008, when Huntington Beach was finally granted the trademark rights to the name, it solidified HB's place as the personification of "Surf City, USA." At its heart, it had always been a surf city. (Just ask any of the surfers shooting the pier here over the past 100-plus years.) Now it was official.

From Freeth's exhibition to Bud and Gene's first planks, Duke's visits, the Keoki's board room, Gordie's shop, the pier's contests, the Greek's designs, the Hole in the Wall Gang Surf Team's trophies, Llamas's gouging turns, and Natalie's museum, surfing was and always has been a way of life in Huntington Beach. This ride continues as HB's surf scene enters its modern era. Sure, there may be a few more dogs surfing now than when Bud Higgins first paddled out, but the spirit is still the same. At least it is for the community who helped turn HB into what is today. This surf family, its members, and their shared experiences are what make Huntington Beach a true surf city.

While everyone else is left discussing the details, they will be out catching a wave and having some fun.

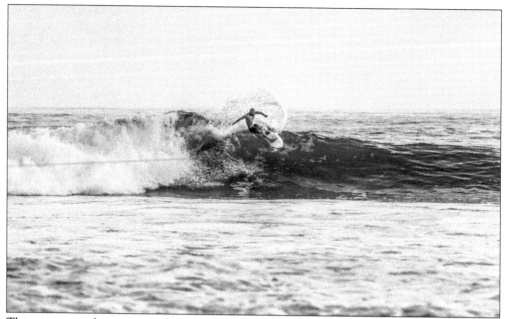

The waters are a lot more crowded and the surfing a lot more extreme than when George Freeth first rode into town, but one of the best parts of HB is that its miles of unbroken beach provide more than enough opportunities for anyone interested in "walking on water." Or in this surfer's case, shredding on water. (Photograph by Teddy Kelley, courtesy of Unsplash.)

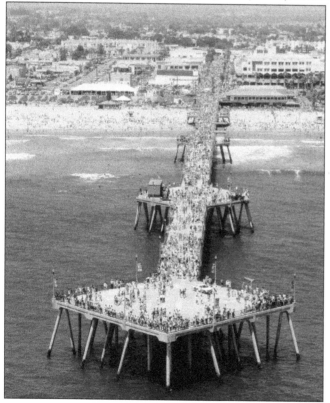

On July 18, 1992, the newly constructed 1,856-foot long pier was rededicated, 78 years after Freeth helped celebrate the original concrete pier's opening. The PIER (Persons Interested in Expediting Reconstruction) Committee raised over $100,000 selling "Pieraphernalia" to help bring back HB's iconic landmark, which by now was part of the US National Register of Historic Places. (Courtesy of the City of HB Archives.)

This is a view of "the Times Square of Surfing" at the corner of Main Street and PCH. The two pillars of Huntington's modern surf scene stand front center. At left is Jack's Surfboards with its Surfing Walk of Fame sidewalk. Huntington Beach Surf & Sport is right, overlooking the cemented handprints of those inducted into the Surfers' Hall of Fame. (Courtesy of Myron Radawiec.)

In 1994, a group of local surfers founded the HB Surfing Walk of Fame. Dedicated to Duke Kahanamoku's spirit, each year ballots are mailed out to select candidates for one of its five categories: Surf Pioneer, Surf Champion, Woman of the Year, Surf Culture, and Local Hero. The sixth category (whose plaques are seen here) recognizes those that don't qualify for the others and is chosen by the board of directors. (Author's collection.)

Huntington Beach is also home to the Surfers' Hall of Fame, founded in 1997. HSS owner Aaron Pai created his tribute to connect future generations with past legends and provide a "permanent public showcase for the achievements of those who have shaped and revolutionized the sport." The closest slab here honors Jericho Poppler. (Courtesy of the City of HB and Visit HB.)

As Jan and Dean sang it best, "I bought a '30 Ford wagon and we call it a woodie / You know it's not very cherry, it's an oldie but a goodie." An enduring staple of surf culture, Woodies are the official car of Surf City, USA. Each year in March, they, along with Volkswagens, roadsters, and other coastal classics line downtown in a throwback to surfing's Golden Age during the Huntington Beachcruiser Meet. (Courtesy of Melanie Radawiec.)

For over 50 years, the Sugar Shack Café has served tourists and locals alike on Main Street. In 1979, Michele Turner took over the business from her parents and turned it into a modern-day surfer haunt. Helped run by her two sons Timmy and Ryan, both legendary surfers in their own right, it provides a home base for HB's surf family, with generations congregating to talk story, discuss conditions, and above all else, eat. (Author's collection.)

Rick "Rockin' Fig" Fignetti is the voice of HB. For over two decades, Southern California listened to his morning surf reports as KROQ/106.7 FM's resident "surfologist." He has also announced countless local contests and events, including the US Open of Surfing for 19 consecutive years. Here, he emcees a 1990s contest joined by seven-time ASP world champion Layne Beachley. (Courtesy of Rick "Rockin' Fig" Fignetti.)

Rockin' Fig stands outside his surf shop at 316 Main Street. Opened in 1990, Rockin' Fig Surf Headquarters is an old-school shop housing vintage boards, a revolving door of local legends and groms, and an impressive collection of trophies won over Fig's surfing career competing in NSSA and West Coast championships. (Courtesy of Rick "Rockin' Fig" Fignetti.)

A few doors down from Rockin' Fig's surf shop is another throwback to HB's surfing past. Following the closure of his own shop, Bob Bolen became a real estate broker and opened Huntington Beach Realty, which doubles as a museum of photographs, trophies, memorabilia, and vintage boards from the Greek's impressive collection of surfing history. (Author's collection.)

In 2000, Bob Bolen and Mike "Mickey Rat" Ester started the International Surfboard Builders Hall of Fame. Its Hawaiian crested logo is inscribed with a phrase translated as "Remember the past to preserve the future." The first inductee was Bill Holden, who here joins several other recipients. These include (standing from left) Gordie Duane, Renny Yater, Bing Copeland, and Dale Velzy. Kneeling are the Greek and Holden. Standing far right is Mickey Rat, who handmakes all the trophies. (Courtesy of Bob Bolen.)

HB may have fewer surf shops than during its Surf Ghetto days, but it still boasts some of the best around. One of the most authentic and laid-back is the 17th Street Surf Shop, opened in 2009 by local surfer Jerry Mulford and hometown hero Bud Llamas. Llamas eventually took over as "soul" owner, offering a welcoming surfing spirit with local community vibes. (Author's collection.)

This poster was created by local artist Rick Blake for "HB 80s," the last leg in the Triple Crown of Retro Surfing (along with "Surfside Seventies" and "Sunset Sixties.") At these events, co-organized by Blake, riders surf on boards from each respective era. More than just contests, they pay tribute to those who paved the way for where we are today, all in the name of good times. This poster features Bud Llamas, who hosts HB 80s. (Courtesy of Rick Blake.)

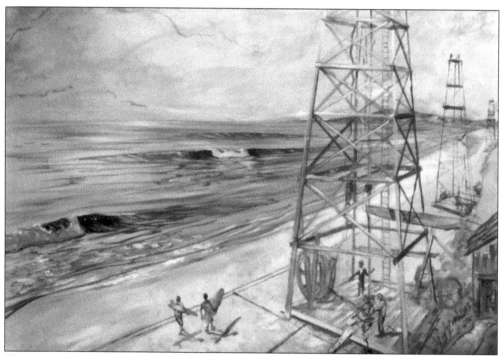

This painting, titled *Surf and Oil* by Rick Blake, evokes Huntington Beach's transformation from oil town to surf city, one in a series highlighting HB's history. Blake grew up riding his bike through the oil fields to surf Bolsa Chica. Today, he is a fixture of HB's surf scene, representing the undercurrents and social settings connected with surf culture through his art. (Courtesy of Rick Blake.)

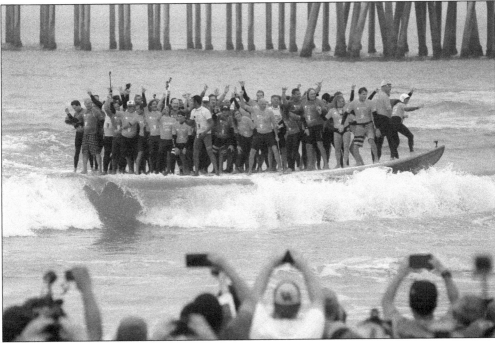

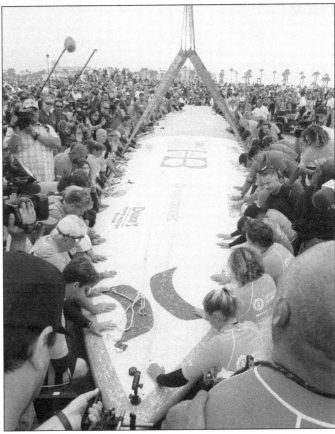

Huntington Beach made the world record books not once, but twice on June 20, 2015, with the Epic Big Board Ride. Above, Jericho Poppler, Brett Simpson, Kim "Danger Woman" Hamrock, and David Nuuhiwa (noseriding, of course) are joined by a who's who of local surfers to break the record for most people riding a surfboard, clocking in at 66. At right, Sumo Sato (bottom-right corner) conducts a traditional blessing prior. At 42 feet long and over 1,300 pounds, this board also holds the Guinness World Record as the world's largest surfboard. Today, it continues its legacy as a great photo op mounted outside HB's International Surfing Museum. (Both photographs, courtesy of the City of HB and Visit HB.)

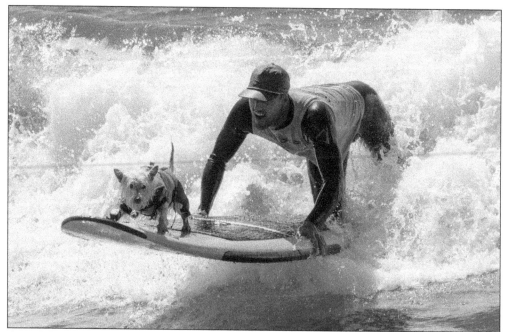

A surf dog rides the nose during a tandem session at the Cliffs. Each year during September, this spot (better known to this furry dude as Dog Beach) hosts Surf City Surf Dog, the premier event on the competitive dog surfing circuit. (Yes, there is such a thing, and it is as wonderful as it sounds). Started in 2009, the contest perfectly fuses HB's surf and dog culture. (Courtesy of John Yeski/FilmAndPixels.)

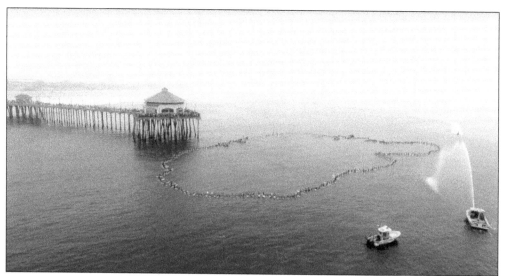

On June 20, 2017, a total of 511 surfers (and one surf dog) formed a circle beyond the pier to set a third Guinness World Record with the largest recorded "Circle of Honor." The ceremony typically honors surfers after they have passed. On this occasion, it was held to support surfing in the 2020 Olympics and promote Huntington Beach as a future location for the event. (Courtesy of the City of HB and Visit HB.)

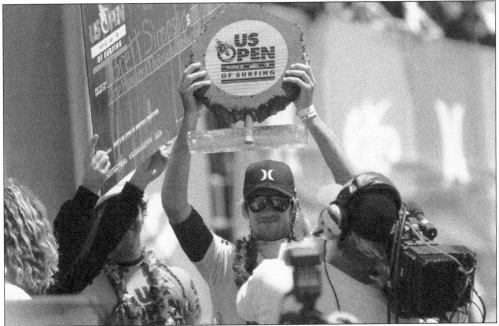

In 1994, the Op Pro was replaced by the US Open of Surfing. A weeklong extravaganza held in midsummer, it continues HB's tradition first begun in 1959 of hosting California's preeminent surfing contest. In 2009, during the 50th anniversary of the first contest by the pier, hometown surfer Brett Simpson won the event amidst gigantic 15-foot-plus surf. He then repeated the following year. (Courtesy of Dave Rugh, dr3x / Flickr.)

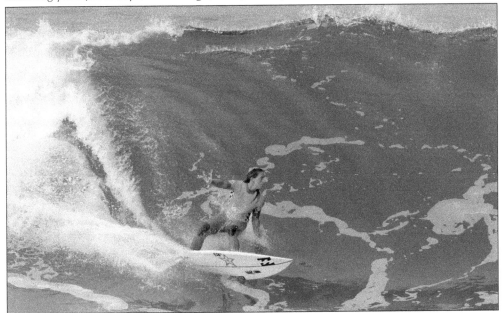

Hailing from Santa Ana, Courtney Conlogue is one of the best pro surfers to ever come out of the area, using local knowledge of her home break to win the US Open of Surfing in both 2009 and 2018. On both occasions, she was joined on the podium by fellow HB locals Brett Simpson and Kanoa Igarashi. (Courtesy of bdapictureco.)

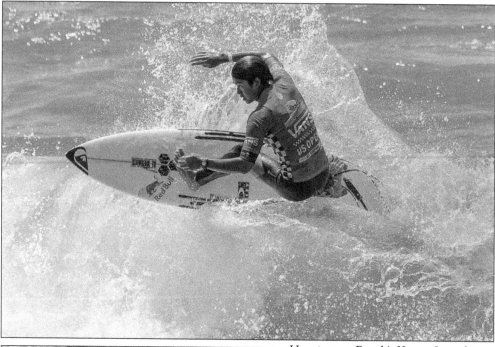

Huntington Beach's Kanoa Igarashi carves a wave during the 2017 US Open of Surfing. That year, Kanoa made his hometown proud by taking the crown and then repeated in 2018 in even more dramatic fashion. The World Surf League (formerly the ASP) proclaims its annual event "the largest professional sports competition and action sports festival in the world." In other words, it is just as epic as ever. (Courtesy of Nam Le.)

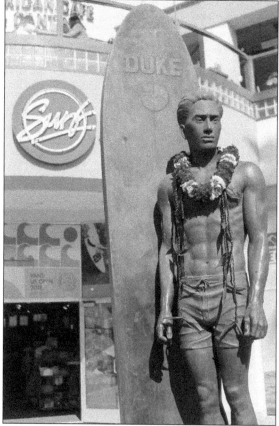

At the corner of Main Street and PCH stands Duke Kahanamoku. This bronze statue looks out beyond the pier toward surfing's birthplace in Hawaii, recalling the impact he, his friend Freeth, and those they inspired like Bud Higgins and Gene Belshe, have had on Huntington Beach and the surfing world at large, while also keeping an eye on modern-day wave-sliders enjoying HB's break. (Author's collection.)

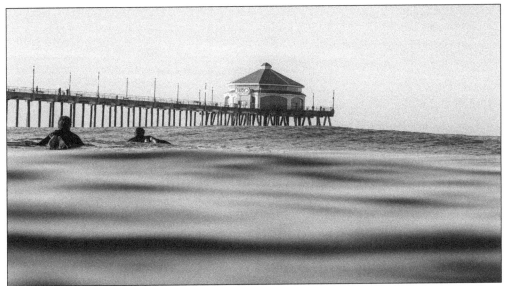

Take away the contests, the music, the industry, the business, the kooks, the hodads, the queebies, the fashion, the trophies, the money, and what is left? Surfing and "the most supreme pleasure" it provides. All it ever was about was paddling out, catching a wave, and having some fun. (Photograph by Jeremy Bishop, courtesy of Unsplash.)

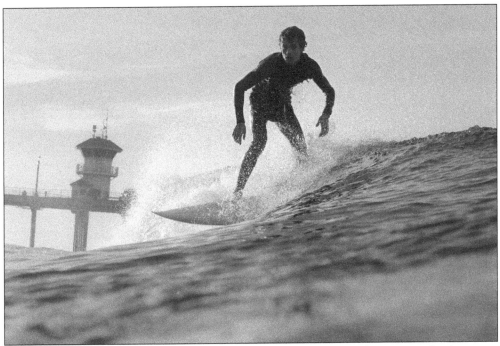

Whatever happens on land, be it gushing oil rigs, suburban expansions, downtown redevelopments, commercialization, or trademark debates, those that live here, visit, or pass through can always count on one thing—a never-ending stoke. Because the surf is always up in HB. (Photograph by Jeremy Bishop, courtesy of Unsplash.)

Visit us at
arcadiapublishing.com